DeLand

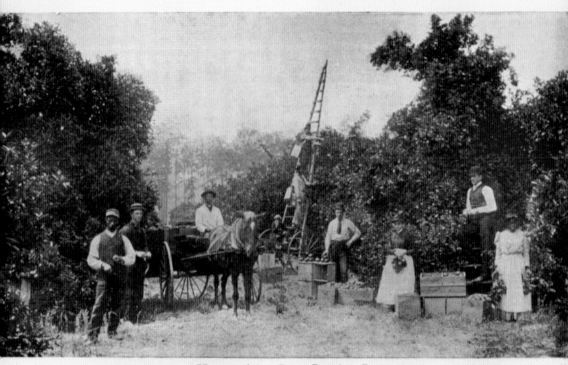

Harvesting Our Staple Crop.

"HARVESTING OUR STAPLE CROP." Many pioneers came to Florida and Volusia County because of "orange fever." This is what brought and kept Henry DeLand here. Seated in the wagon is the owner of the pictured grove, Lue Gim Gong. Having developed a late-blooming and cold-resistant orange, Lue Gim Gong was nicknamed "the Citrus Wizard." A native of Canton, China, he immigrated to America when he was 12 and moved with his benefactor Fanny Burlingame to DeLand in 1886 for health reasons. (Author's collection.)

ON THE FRONT COVER: STREET SCENE. This 1940s image is looking north on Woodland Boulevard, just south of the intersection with New York Avenue. To the right is the Dreka or Whitehair Building, which for many years housed J.C. Penney on the bottom floors; today, offices and the Mainstreet Grill in the basement occupy this building. Also visible are the multi-storied Barnett Bank Building and McCrory's on the east side of the road and Rexall Drugs and Piggly Wiggly on the west side.

ON THE BACK COVER: STETSON HALL. Erected in 1886, this was the second building on the campus of DeLand College, which was renamed John B. Stetson University in 1889 for Stetson's financial support of the school. The building was demolished in July 2011 due to its poor condition after 125 years of use as a residence hall. Renovation was ruled out because the structure was significantly altered in 1946 from its historic condition. It was one of many buildings on the campus reported to be haunted. (Author's collection.)

POSTCARD HISTORY SERIES

DeLand

L. *Thomas Roberts and the West Volusia Historical Society*

ARCADIA
PUBLISHING

Published by Arcadia Publishing
Charleston, South Carolina

Printed in the United States of America

Library of Congress Control Number: 2013949988

For all general information contact Arcadia Publishing at:
Telephone 843-853-2070
Fax 843-853-0044
E-mail sales@arcadiapublishing.com
For customer service and orders:
Toll-Free 1-888-313-2665

Visit us on the Internet at www.arcadiapublishing.com

In memory of my dad, Loyd Thomas Roberts II, who fueled my love for history by taking me to historic sites whenever we traveled together.

CONTENTS

ACKNOWLEDGMENTS

The retelling of DeLand's history in any form would be impossible to do today if it weren't for the efforts of so many of the early settlers in recording their stories. People like Hettie Austin who was secretary of the Old Settlers Club, Helen Parce DeLand who wrote of her years in DeLand and Lake Helen, and Vincent Ward Gould who wrote newspaper columns of his years growing up in DeLand prior to the turn of the 20th century. I think this early respect for the history of our town has been passed on to many others who have grown up or lived in DeLand for a long time, leading to the formation of the West Volusia Historical Society in 1973. The society's mission to preserve and promote the history of West Volusia County has been taken to a new, unparalleled level by executive director Bill Dreggors and has resulted in many books published by the society that are the backbone of the stories told in this book. Office manager Eric Dusenbery and curator Billy de Silva were always very helpful when I visited the Conrad Research Center and it has been my pleasure to collaborate with them as well as former office manager Rhonda Janitch on many society projects. Board members Mary T. Clark and Caryn Long, along with her husband, Lewis, were gracious to review the manuscript and provide feedback.

If the books of the society are the backbone of this work, then Jim Cara, longtime DeLandite and owner of Carasells Pop-Culture Collectibles in DeLand, has put the flesh on the bones by generously allowing me access to his colossal collection of DeLand area postcards and sitting with me a number of nights to discuss ideas for the book. Unless otherwise noted, all images appear courtesy of Mr. Cara.

Linda Harrod also spent hours reviewing the manuscript, providing feedback that was greatly appreciated. I also wish to thank my editor at Arcadia Publishing, Liz Gurley, for her expert advice and patience with my slow and methodical research and writing. A special thank-you goes to Pam White Weeks for encouraging me when things were not going as planned, if I was hitting a research roadblock or struggling with writer's block.

Finally, to my mom and to my children, Jennifer, Katie and Ben, thank you for your love and for allowing me to disappear at times to complete this project.

INTRODUCTION

In the spring of 1876, Henry Addison DeLand, a baking soda or saleratus manufacturer from Fairport, New York, was invited by his brother-in-law Oliver P. Terry to visit his homestead in Central Florida. It had only been 22 years since Volusia County was carved out of Orange County by the Florida legislature. Enterprise was the county seat, and the town that would become DeLand's namesake was a sparsely populated area known as Persimmon Hollow. But all of that would soon change when Henry DeLand came to town.

Although he only spent one day in the area, he was so impressed with the wide-open pinelands and potential that he spent the summer planning a city in the pine forest. This was not to be any ordinary town. As Athens was the European center for the arts, learning, and philosophy, Henry DeLand envisioned a town that would become "a religious, educational, business, and social center"—the Athens of Florida, as it was later nicknamed. He returned to DeLand in October 1876, and in December of the same year, he called on the settlers of the surrounding area to attend a second meeting at the Rich cabin. Here, he outlined his plan and offered an acre of land for building a combination school and church and funding for half the construction cost. He also offered to donate a 60-foot-wide strip of land extending one mile to the north from New York Avenue to be cleared for a road, planted with trees, and named Woodland Boulevard. During this same meeting, the settlers voted to name the new community DeLand for its architect and founder.

Over the next two years, Henry DeLand wintered in DeLand but sold his interests in the DeLand Chemical Company to move to DeLand full time because the town was not progressing as fast as he desired. He built a home on the 100 block of West Michigan Avenue and began to fully invest his time and money advertising the attributes of the city. This civic mindedness fell in line with his conviction that he would use any wealth he accumulated for benevolent purposes. By matching funds raised by the townspeople, DeLand was able to build the first school, the first church, DeLand Landing, and the DeLand Academy.

The first-year classes of DeLand Academy were held at First Baptist Church. The first building, DeLand Hall, was built in 1884 on the four-acre campus. When college-level classes were added, the school was renamed DeLand College, and in 1887, the Florida legislature chartered the school as DeLand University. While Henry DeLand supported the school, he used his business and church connections to bring teachers, other investors, and philanthropists to DeLand, the most notable being John B. Stetson. From the time John Stetson came to DeLand in 1886, he took an interest in the school and donated the first $1,000 toward the cost of building a sorely needed residence hall, the second building on campus, which was named in his honor. In May 1889, Henry DeLand requested that the name of the school be changed to John B. Stetson University, and from this point on, the history of DeLand and Stetson University has been intertwined.

The time and effort Henry DeLand invested in his town paid off. DeLand incorporated March 11, 1882, and adopted a seal with a Latin cross, anchor, and heart, reflecting the Christian values of faith, hope, and charity that were so dear to its founders. It became the first city in Florida and one of the first in the nation to have electricity when the town council approved an ordinance in 1887, approving the construction and maintenance of an electric lighting plant in the city. The plant would be known as the DeLand Electric Light, Power and Ice Company, or DELPICO, and was owned in part by John Stetson, a friend of Thomas Edison. On March 29, 1888, an election was held to determine whether the county seat would remain in Enterprise. DeLand received 1,003 votes, a majority margin of 142 votes. The two factors believed to have influenced the vote were that Henry DeLand agreed to donate the site for the courthouse and he, John Stetson, and Fred Goodrich gave the county commissioners a $15,000 bond covering the cost of the construction if the county seat was legally relocated to DeLand. The move brought new jobs, business, and prestige to the rapidly thriving community.

In 1900, Stetson University opened the first law school in Florida, bringing some of the brightest minds and future leaders to DeLand. The first law professor, Carey D. Landis, would be one of the cornerstones of the Courthouse Ring, or simply the Ring, along with his student Bert Fish, a member of the first graduating law class. The Ring would wield political power and influence not only in Volusia County but also throughout the Florida political landscape, helping men get elected at local, county, and state levels. Landis would serve as attorney general under political rival and fellow Volusian Gov. David Sholtz, and was in a position to run for governor before his untimely death in 1938. Fish ran the Florida Democratic campaign for Franklin Roosevelt in 1932 and was rewarded by Roosevelt when he was appointed ambassador of Egypt and Saudi Arabia. His friendship with the Saudi king was instrumental in the American Oil Company's getting the contract to drill for oil in that country.

To this day, Deland continues to be a cultural and educational center with a strong religious heritage and a thriving business community and downtown. Many of the people, places, and stories that have contributed to the continuing success of Henry DeLand's dream for his namesake city are reflected in the postcards presented in the following chapters.

One

Henry DeLand Comes to Town

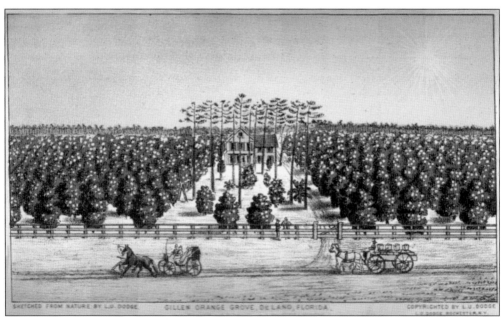

GILLEN ORANGE GROVE. After arriving by steamboat at Enterprise, Florida, Henry DeLand boarded a one-horse rig for the trip to O.P. Terry's homestead and Persimmon Hollow. Initially, he begged to turn around because the country was so desolate, but when he saw the open pinewoods, rolling hills, and an orange grove, he began to realize how promising the area would be. Dr. H.H. Gillen was the first physician in DeLand, and he owned a homestead west of town prior to 1876. John B. Stetson later purchased his property and kept Gillen as the name of his orange grove.

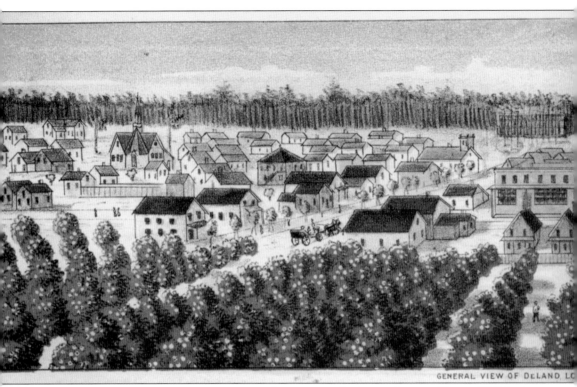

GENERAL VIEW OF DELAND, LC

"GENERAL VIEW OF DELAND LOOKING EAST FROM DELAND GROVE HOUSE." This view of the fledgling city of DeLand was sketched during the early 1880s, probably 1884 since DeLand Hall is referred to as the "new academy." All of the views in this chapter are from a precursor to the postcard that was distributed by Henry DeLand and J.Y. Parce to advertise the benefits

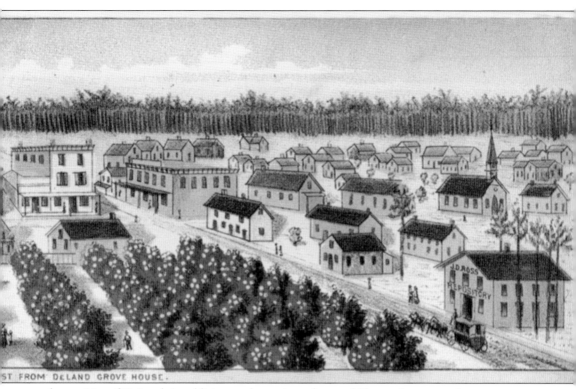

ST FROM DELAND GROVE HOUSE.

and amenities of DeLand. In addition to these views that could be used to transmit messages on the back, the inside cover of the booklet indicated DeLand had a population of 1,000 to 2,000 in and near the city. Land was offered for purchase for $20 to $100 per acre.

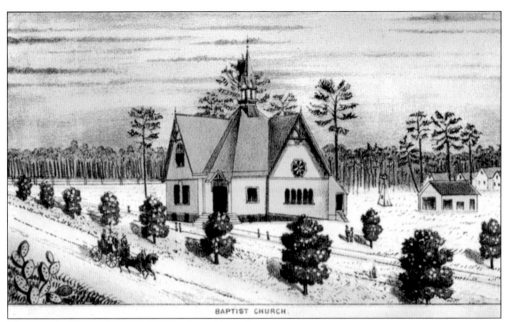

BAPTIST CHURCH.

BAPTIST CHURCH. First Baptist Church, dedicated April 16, 1882, was built on East Rich Avenue on land donated by Henry DeLand for $1. Henry DeLand also paid a portion of the first pastor's annual salary. It was the first full-time church building in DeLand. The congregation formed October 31, 1880, with 13 members. Prior to its construction, members met in homes or at the first schoolhouse.

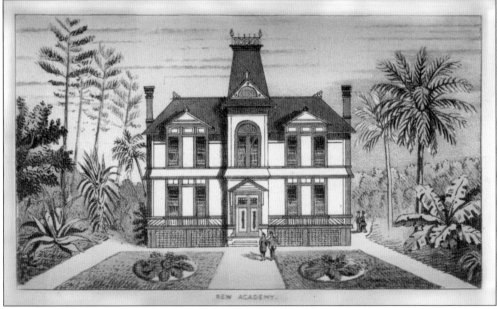

NEW ACADEMY.

NEW ACADEMY. DeLand Hall was built in 1884 on land donated by Henry DeLand, who also gave generously for the construction. DeLand Academy, formed November 5, 1883, was located on a four-acre parcel at the north end of Woodland Boulevard near the intersection of Minnesota Avenue today. The first year, classes met in the Baptist Church. DeLand Hall is the oldest continuously used college building in Florida.

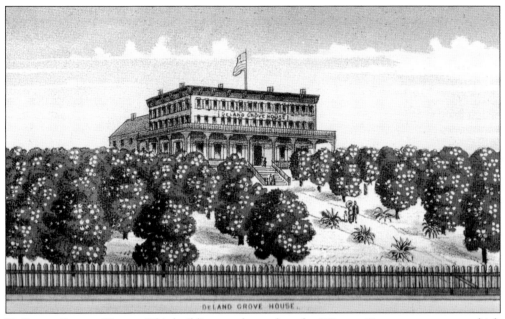

DeLand Grove House. This building was located on the 159-acre Hampson property, which Henry DeLand purchased during his first visit to the area. Construction of the DeLand Grove House started in 1876 under the supervision of Julian J. Banta, who was invited by the Rev. Menzo Smith Leete, Henry DeLand's brother-in-law, to supervise this project and the erection of the Parce Land Home. Once completed, O.P. Terry was proprietor of the hotel.

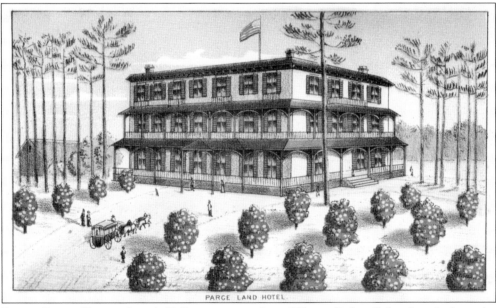

Parce Land Hotel. Joseph Y. Parce was another of Henry DeLand's brothers-in-law who turned a large nine-to-ten-room home into the Parce Land Hotel in the early 1880s. John B. Stetson purchased this hotel and added onto it significantly. It was located where the current county courthouse sits today on Alabama Avenue.

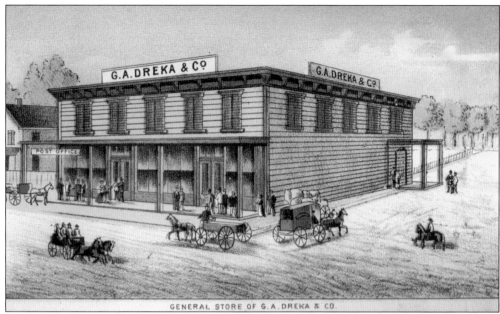

GENERAL STORE OF G.A. DREKA & CO.

GENERAL STORE OF G.A. DREKA. On November 12, 1878, George Augustus Dreka purchased the mercantile store of J.B Jordan. This was the beginning of what was to become the largest department store in Volusia County for nearly a half century. According to Helen P. Deland, DeLand became a center of trade from this time. Dreka stocked items not available previously and employed marketing strategies such as free lunches. His motto was "everything to eat, wear, and use."

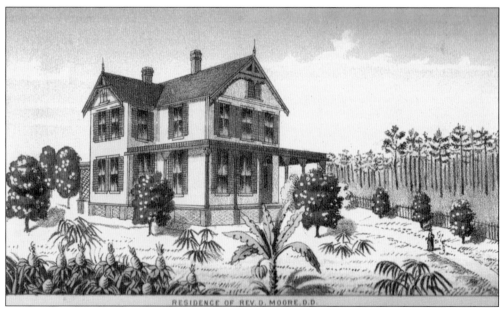

RESIDENCE OF REV. D. MOORE, D.D.

RESIDENCE OF REV. D. MOORE, DD. The Rev. David Moore was a member of DeLand College's first board of trustees, appointed by the Florida Baptist Convention of December 1885. He continued to serve as a trustee of Stetson University through the turn of the 20th century. He lived in Rochester and later Geneva, New York. A friend of Henry DeLand's, he recruited Dr. Forbes to be the first president of what would later become Stetson University.

Two

STETSON UNIVERSITY

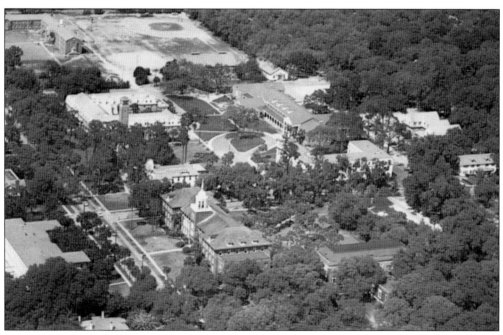

AERIAL VIEW OF STETSON UNIVERSITY. Stetson University is a private, nonprofit university that annually ranks as one of the finest in the Southeast. Founded in 1883 and affiliated with the Baptist Church, it currently consists of four colleges and schools located across Central Florida. Stetson severed its official ties with the Florida Baptist Convention in 1995, ending their 100-year relationship. This view dates to the late 1950s or early 1960s.

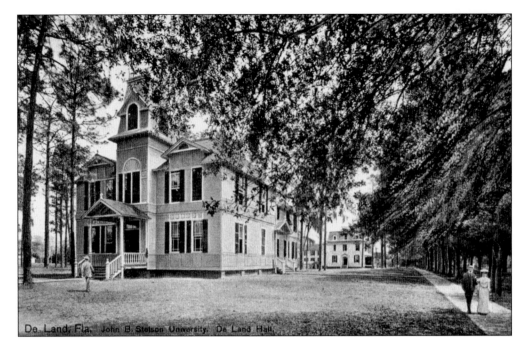

DeLand Hall. Stetson University started simply as the DeLand Academy on November 5, 1883, with 13 students meeting initially in the Baptist church building. The principal and pastor of First Baptist Church was Dr. John H. Griffith, who was brought in by Henry DeLand from New York. Students occupied the new two-story DeLand Hall on October 13, 1884, with a new enrollment of 88 students. Dr. John F. Forbes came to DeLand in the summer of 1885 to become president of then DeLand College.

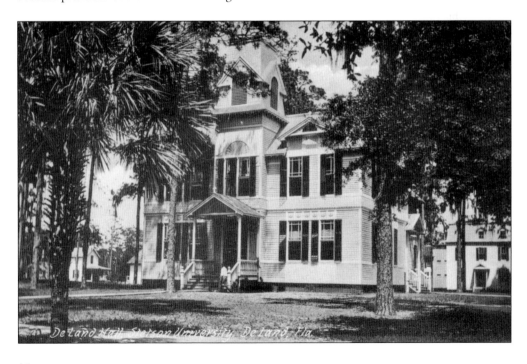

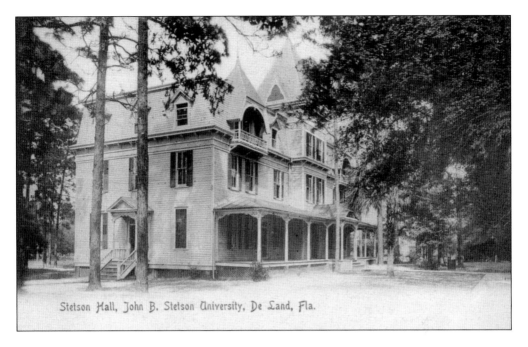

Stetson Hall, John B. Stetson University, De Land, Fla.

STETSON HALL. With a rapidly rising student population, Henry DeLand knew a residence hall would be a necessity, so after pledging $1,000 of his own money, he appealed to the Florida Baptist Convention for the estimated $7,000 needed. C.T. Sampson, a shoe manufacturer from Massachusetts, pledged $1,000 after hearing of the need during a winter stay at the Harlan Hotel in Lake Helen. Still short, John B. Stetson stepped in with $3,500, and the new structure was named for him. The new building was described as having "beauty, symmetry, and proportion everywhere." The renovation in 1946, seen below, robbed this Victorian masterpiece of its beauty, which ultimately contributed to its demise in 2011.

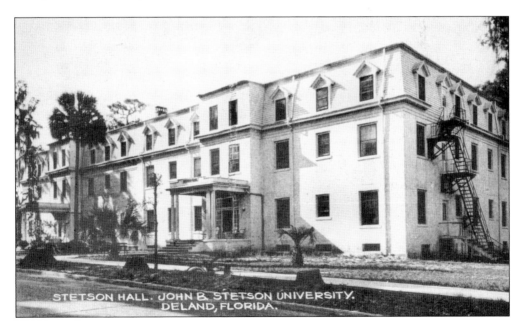

STETSON HALL. JOHN B. STETSON UNIVERSITY. DELAND, FLORIDA.

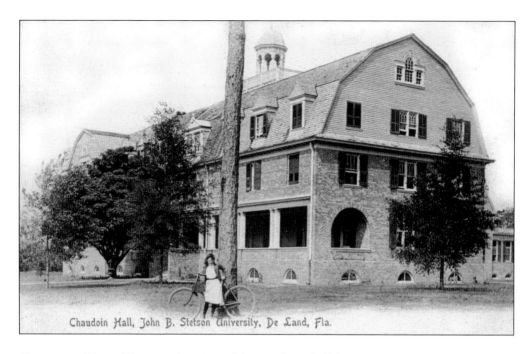

Chaudoin Hall, John B. Stetson University, De Land, Fla.

CHAUDOIN HALL. The central section of this residence hall for women was built in 1892, with a north wing added in 1894. It was named for the beloved Dr. W.N. Chaudoin, who served as president, secretary, and treasurer of the Florida Baptist Convention. He was a Stetson trustee and the first person to receive an honorary degree from Stetson. The north wing, added in 1894, was paid for by C.T. Sampson and was referred to as Sampson hall for some time. A south wing was added to the building in 1935. Not only did the structure provide much needed living space for female students, but it also served as the home of the dean of women.

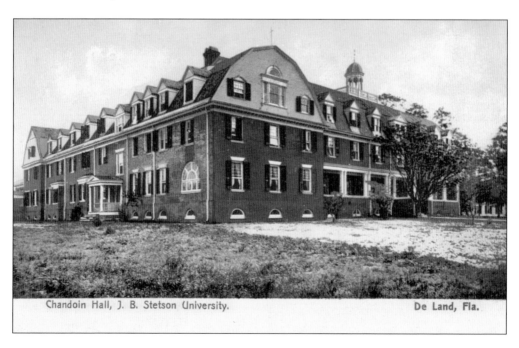

Chandoin Hall, J. B. Stetson University. De Land, Fla.

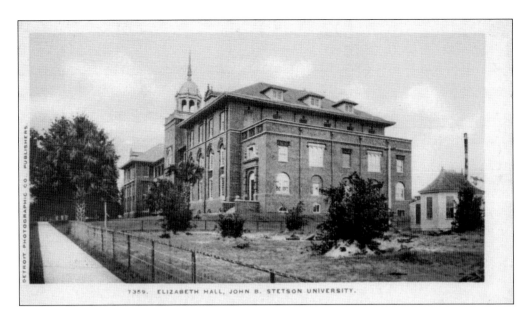

7359. ELIZABETH HALL, JOHN B. STETSON UNIVERSITY.

ELIZABETH HALL. Named for John B. Stetson's wife, Elizabeth, the central section of the building was constructed in 1892. It was designed to resemble Independence Hall in Stetson's hometown of Philadelphia. John B. Stetson had two additional wings added in 1897. The total cost of the construction when completed was $125,000 more than the total combined cost of all other Florida higher-education buildings to that date. The south wing contains a 786-seat chapel with the first pipe organ in the state. In the early days, the tower contained a water tank that supplied water for the campus until 1915, when city water was available. That same year the Eloise chimes were installed and remained until 1934, when Hulley Tower was completed.

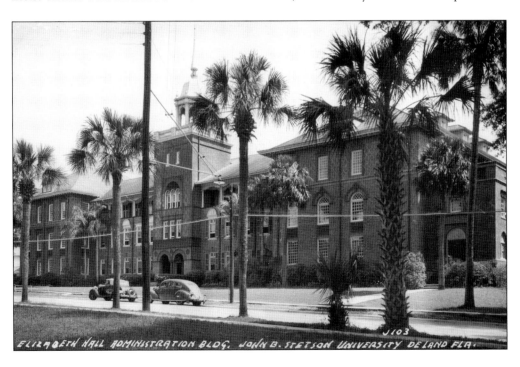

ELIZABETH HALL ADMINISTRATION BLDG. JOHN B. STETSON UNIVERSITY DE LAND FLA.

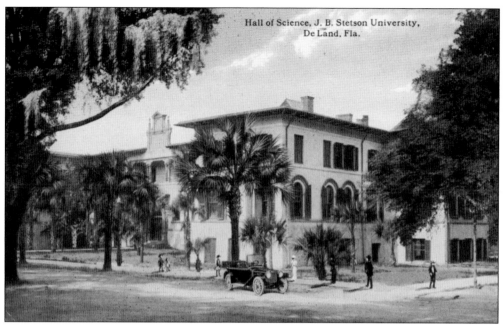

Hall of Science, J. B. Stetson University,
De Land, Fla.

SCHOOL OF TECHNOLOGY AND HALL OF SCIENCE. Railroad baron Henry M. Flagler financed this building for $60,000, but required Stetson to keep the gift a secret because he feared other schools would ask him for money if word got out. A condition of the gift was that Flagler dictated its design, a Mediterranean style he used for other projects in St. Augustine and Palm Beach. Watching over the main entrance of the building is a bust of Benjamin Franklin that is frequently mistaken for Shakespeare or other historical figures. Only after Flagler's death in 1913 did Stetson rename the building Flagler Hall in his honor. When it opened in 1902, Flagler Hall was the home of science classes and Florida's first law school, which remained there until World War II when it was temporarily closed. The Stetson University College of Law relocated to Gulfport, Florida, in 1954.

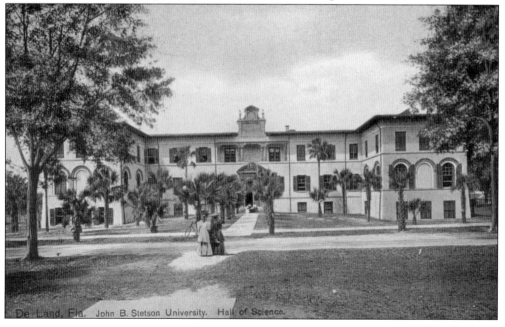

De Land, Fla. John B. Stetson University. Hall of Science.

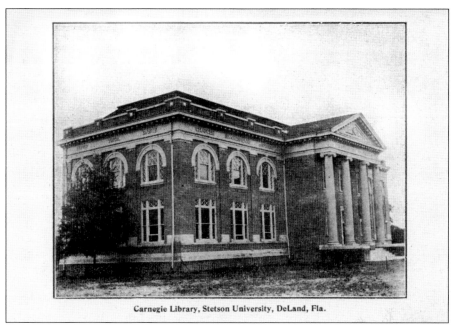

Carnegie Library, Stetson University, DeLand, Fla.

CARNEGIE LIBRARY. Built in 1908 at a cost of $40,000, with money donated by philanthropist Andrew Carnegie, the library was designed by Henry John Klutho. Klutho designed many of the new buildings and bridges built in Jacksonville after the Great Fire of 1901, the largest urban fire in the Southeast. Stetson's Carnegie Library is one of a small number of Klutho structures remaining in Florida. The library was later renamed Sampson Hall to honor Calvin T. Sampson, a shoe manufacturer from North Adams, Massachusetts, and university trustee who was responsible for bringing a young Lue Gim Gong from San Francisco to work in his shoe factory. He contributed to Stetson's library fund and left an additional $20,000 for a library endowment when he died in 1893. Stetson was the first university in Florida to employ a full-time librarian.

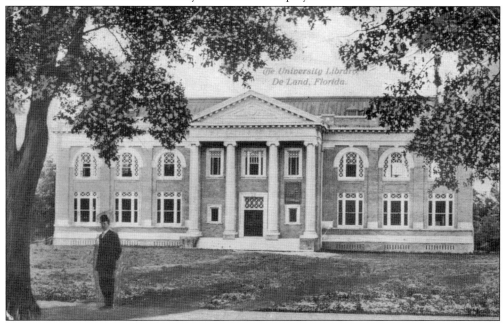

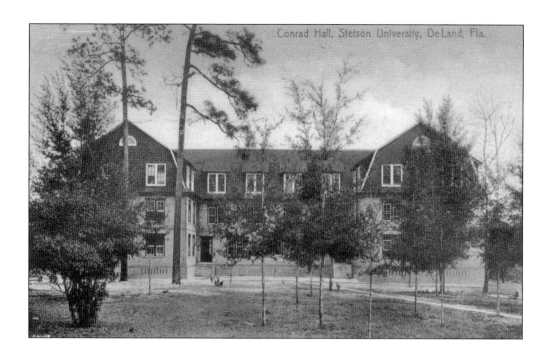

CONRAD HALL. The first Conrad Hall, completed in 1902, was destroyed in Stetson's first serious fire just before the opening of the term in 1903. The second was built in 1909 for approximately $15,000 and was named for Jacob B. Conrad, the largest donor for the building, who was an area lumberman and trustee. The new Conrad Hall was designed by Litchfield P. Colton, who taught engineering from 1906 to 1923 and served as coach for Stetson's early football teams. When it opened, it housed male college and law students.

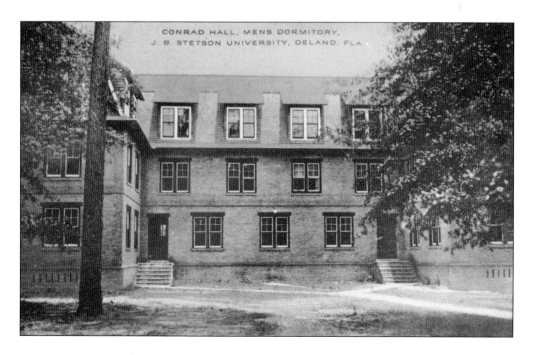

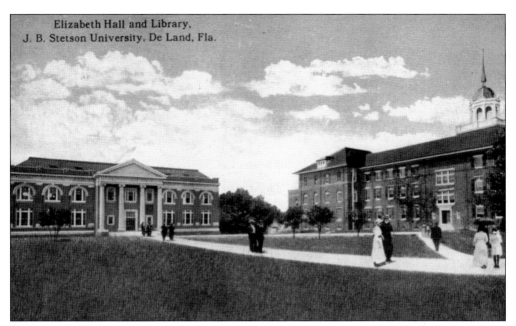

Elizabeth Hall and Library,
J. B. Stetson University. De Land, Fla.

ELIZABETH HALL AND LIBRARY. A triangular walkway connected Elizabeth Hall with the Carnegie Library. Note the parasol at right, used by students for protection from the hot Florida sun. Sampson Hall, as the library was later named, is reported to be one of the most haunted buildings on the campus today. A malevolent spirit is said to push students on the upper floor. Today the building houses classrooms and the Duncan Gallery of Art, named for former president Pope Duncan and his wife, Margaret. (Author's collection.)

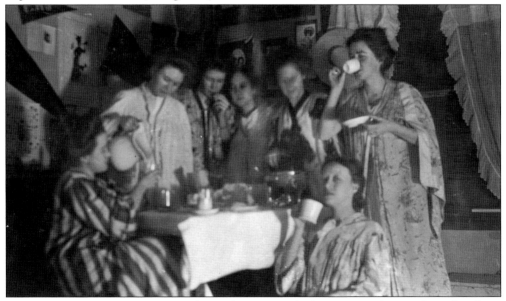

RESIDENCE HALL GATHERING. This early 1900s real-photo postcard came from the photo album of Murray "Pat" Sams. Many of the other photographs with this postcard depict some of the same women outside Chaudoin Hall; presumably this photograph was taken inside that structure, but it could have come from another building. Note the pennants on the walls, which were typical decor for residence halls in that period. (Author's collection.)

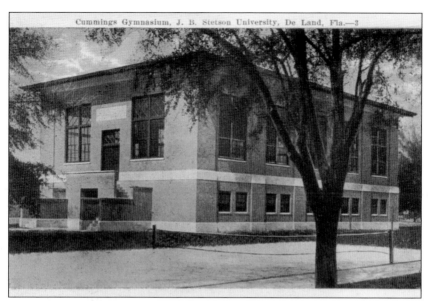

CUMMINGS GYMNASIUM. Built in 1911 for $12,000, this building was named for J. Howell Cummings, who donated $6,000. Cummings was the president of the John B. Stetson Hat Company in Philadelphia. This was the second gymnasium built on the campus; the first, a small wooden structure behind Stetson Hall where the Carlton Union Building is today, was said to be the earliest college gym in Florida. The athletic field on the west side of the building was the location of most of the outdoor athletic events of the day.

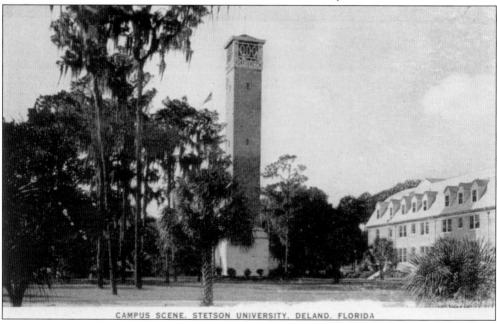

CAMPUS SCENE, STETSON UNIVERSITY, DELAND, FLORIDA

A CAMPUS SCENE. Hulley Tower stood 116 feet tall when it was completed in 1934. Lincoln Hulley served as president from 1904 to 1934; he and his family built the tower as a gift to the university, but President Hulley died before it was finished. The 11-bell Eloise Carillon, named for Hulley's wife, was moved to the tower from the Elizabeth Hall cupola. The upper part of the structure was dismantled in 2005 for safety reasons, leaving the ground floor, which houses the Hulley mausoleum.

24

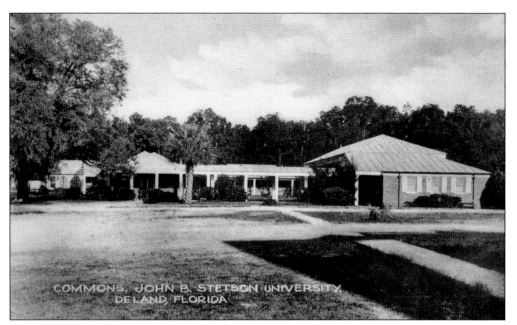

THE COMMONS. During 1936–1937, the Commons was built east of Chaudoin Hall. Food service was moved to this building, which consisted of two cafeterias, a private dining room, and a lounge. The building burned down during Christmas vacation 1954, and the basement of Hulley Gym was used for dining, with meals furnished by Morrison's Cafeteria of Daytona Beach.

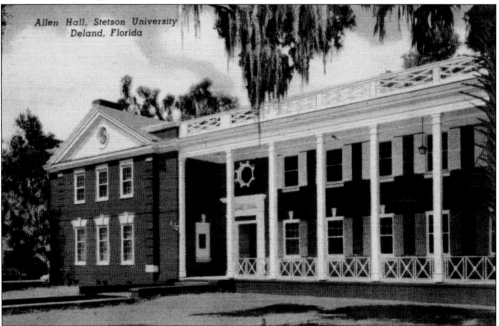

ALLEN HALL. Given by the Florida Baptist Convention to be the center of religious activities for all denominations and dedicated in 1950, it is named for Stetson's fourth president, William Sims Allen. Allen served from 1934 to 1947, having to cope with the challenges of the Depression years and World War II. Allen's inaugural address was carried over the first Florida statewide radio transmission. He resigned due to illness in September 1947.

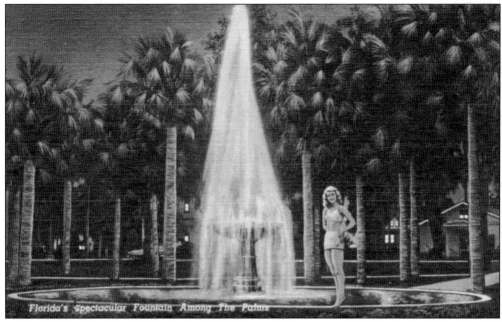

HOLLER FOUNTAIN. The Holler Fountain was installed in Stetson's quadrangle in 1951. The Art Deco–style fountain was built in Central Florida in 1937 for the Florida exhibit at the Great Lakes Exposition in Cleveland and was also featured in the Florida display at the 1939–1940 World's Fair in New York. It was a gift from William E. Holler Jr. of DeLand to honor his father, William. A longstanding Stetson student tradition is to throw fellow students into Holler Fountain on their birthdays.

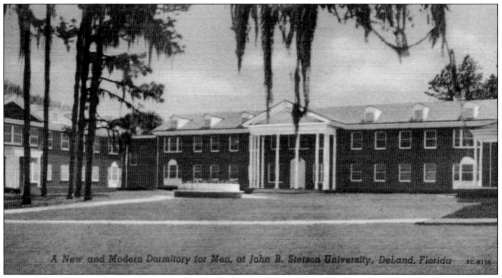

A NEW AND MODERN DORMITORY FOR MEN. Built in 1956, Gordis Hall is located next to Smith Hall, which was erected in 1957. Warren S. Gordis came to Stetson in 1888 to teach Latin and Greek. He served as "acting president" of the university when President Forbes took a leave of absence in 1895–1896. Neither building had air-conditioning until the summer of 1986. Gordis Hall currently serves as home to 140 first-year residents in shared-occupancy rooms. The building has a common area, laundry room, student lounges, and community-style bathrooms on each floor.

THE STETSON UNION. Construction started in 1957 to replace the recently burned Commons. The Stetson Union Building was up and running by the beginning of the 1958 school year. In addition to the dining facilities, it contained a soda shop, post office, bookstore, a bowling alley, and student, faculty, and alumni lounges. On July 1, 1969, the building was formally named the Carlton Union Building for Doyle E. Carlton, former Florida state senator, governor of Florida from 1929 to 1933, and a Stetson alumnus and longtime trustee.

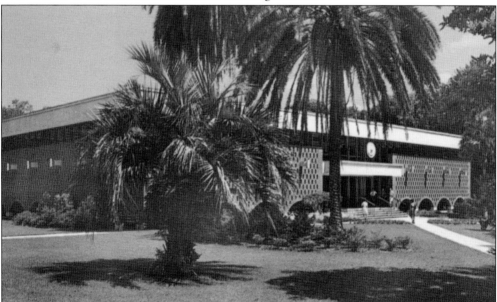

DUPONT-BALL LIBRARY. The duPont-Ball Library, opened in May 1964, was named for two major donors, Mrs. Jessie Ball duPont, a trustee, and her brother, Edward Ball. Its construction required the demolition of Holmes Hall, a historic home built as President Forbes's family residence. It was occupied by the Art Department at the end of its use. The Romanesque arches of this home inspired the architect to incorporate arches in the design of the brick screen around the new library.

27

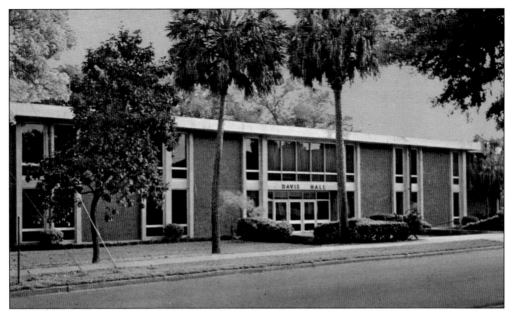

DAVIS HALL. The business school, having grown out of Flagler Hall, was temporarily placed in the old DeLand Naval Air Station Administration Building, which was relocated from the airport to the campus. President Edmunds approached the four Davis brothers from Jacksonville, who were the owners of the Winn-Dixie chain of grocery stores, and they gave $500,000 to cover construction costs. In the fall of 1966, the new home for the business school opened.

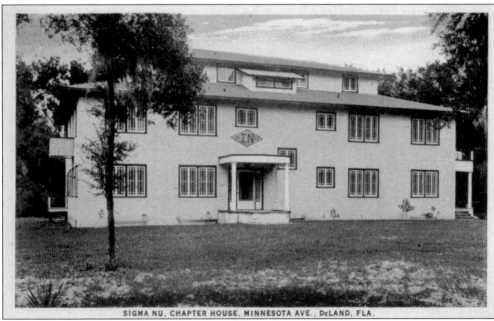

SIGMA NU, CHAPTER HOUSE, MINNESOTA AVE., DeLAND, FLA.

SIGMA NU CHAPTER HOUSE. The Sigma Nu house was located at 230 East Minnesota Avenue prior to construction of the new science building, Sage Hall, and the closing of Minnesota Avenue between Woodland Boulevard and Amelia Avenue in the mid-1960s. Stetson had to buy the fraternity house for $30,000 and provide a lot on East Stetson Avenue to get approval. Sigma Nu is the oldest fraternity on campus.

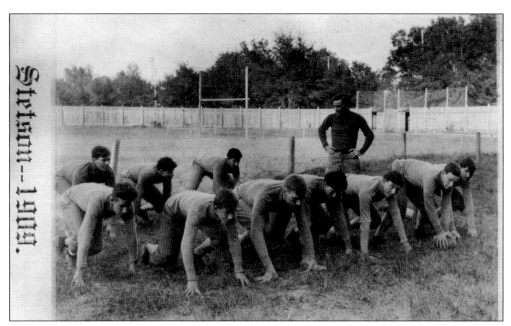

1909 Football Team. Stetson's football team was the Florida state champion team with a 3-0-1 record in 1909. They beat a team identified as Olympic twice, 10-0 and 14-0, and beat Florida in the first of two games 26-0 and played to a 5-5 tie in the second game. This postcard photograph was likely taken on the field that was located between Cummings Gym and the Stover Theater, neither of which were built at this time. (Author's collection.)

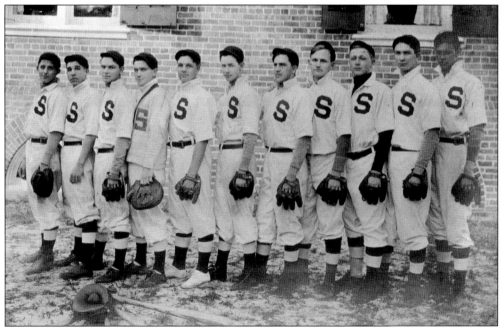

1910 Stetson Baseball. Stetson's baseball team was the Florida state champion in 1910. In the early years, the school did not field a team every season, but there were teams in 1895, 1901–1917, 1919–1925, 1937–1940, and 1947 to today. Bill Swaggerty, who played in the late 1970s, was the school's first player to make it to the Major League level. (Author's collection.)

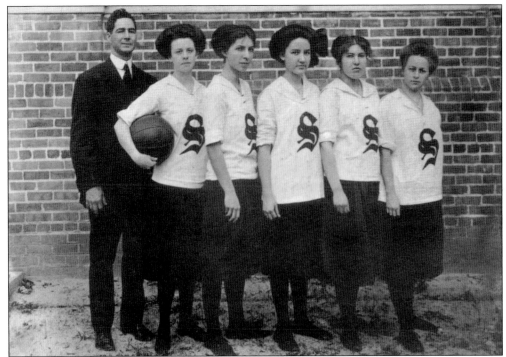

1910 WOMEN'S BASKETBALL. In addition to basketball, women had the opportunity to play intercollegiate tennis. The Stetson Athletic Association did not allow students to wear a varsity "S" unless they had played in three halves of intercollegiate football or basketball, three games of baseball, or five sets of tennis. Pictured from left to right are Botts (coach), Prugh, Wright (captain), Bunch, Post, and Quaterman. (Author's collection.)

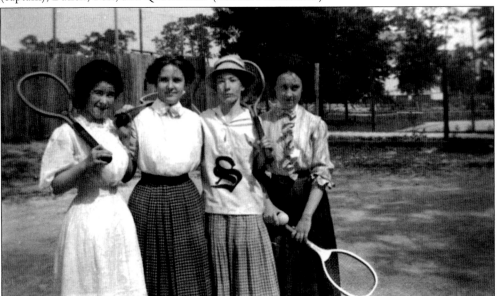

WOMEN'S TENNIS. This c. 1909 photograph of four women who played tennis at Stetson University was taken at the athletic field located at the southwest corner of Woodland Boulevard and University Avenue. One of the women is wearing her varsity "S." (Author's collection.)

Three

ABOUT TOWN

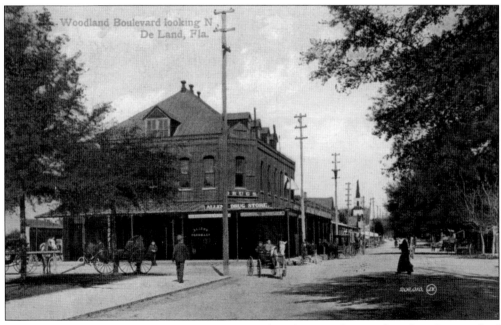

WOODLAND BOULEVARD, LOOKING NORTH. This photograph was taken from just south of the intersection of Indiana Avenue and Woodland Boulevard. Allen's Drugstore occupied the brick two-story building on the left, and the post office was also located here. This card was published as a promotional item for Allen's and was printed by E.O. Painter, a longtime printing company located in DeLand. The building was built about 1893 by R.C. Bushnell, who operated a grocery store in this location prior to Allen's moving in.

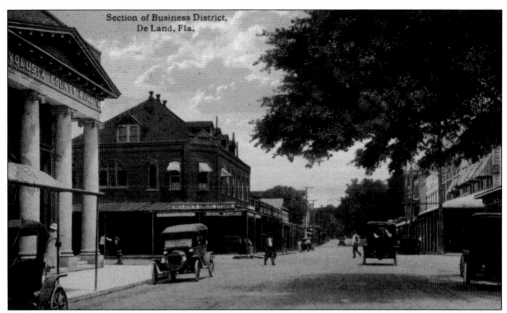

Section of Business District,
De Land, Fla.

SECTION OF BUSINESS DISTRICT. This is a view looking north at the intersection of Woodland Boulevard and Indiana Avenue, dating between 1910 and 1920. The steeple from the Presbyterian church was removed when the church was remodeled around 1909. The building on the right side of the corner is V.M. Fountain's department store, located at 129 North Woodland Boulevard. He offered "gents furnishings, clothes and shoes," including trunks and satchels as well as the best line of shoes for women and children.

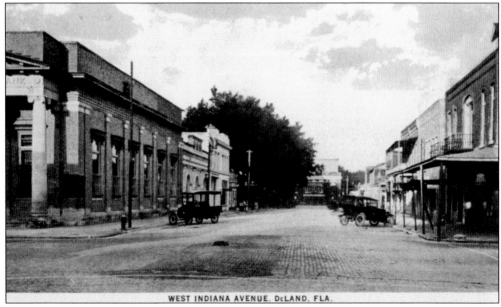

WEST INDIANA AVENUE, DeLAND, FLA.

WEST INDIANA AVENUE. This view from the center of the intersection of West Indiana Avenue and Woodland Boulevard, shows all the buildings on the south side of the street. On the corner is the Volusia County Bank building. Next is the Landis-Fish Building, constructed in 1905 at 110 West Indiana Avenue as a single story but enlarged in 1925 to the two-story Federal structure; it is still standing today and is occupied by Bowyer Singleton & Associates.

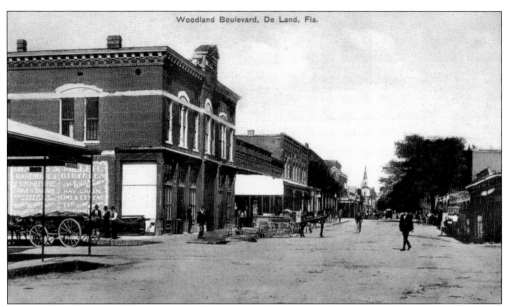

WOODLAND BOULEVARD. Both views were taken at the intersection of Woodland Boulevard and New York Avenue, probably just after the turn of the century since no automobiles are visible. In the postcard above, the large building to the left is the Miller Building, constructed about 1887 after the fire in 1886 destroyed much of downtown DeLand. Charles A. Miller operated a dry goods store and served as an agent for the Clyde steamship line from this building. Later, he opened a hardware store. The building still stands and is currently the home of Mainstreet DeLand. The building on the southwest corner is G.W. Fisher's drugstore. This postcard was published by W.A. Allen and Company and is postmarked 1911. Below, the early arc light fixtures are visible on rough-hewn power poles that are not visible in the above postcard. The Presbyterian church steeple is visible in both views.

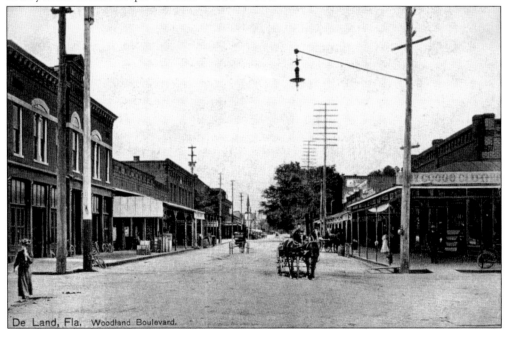

De Land, Fla. Woodland Boulevard.

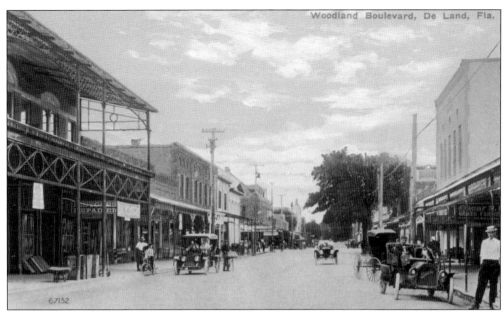

WOODLAND BOULEVARD. This view looking north dates to about 1920. On the left next to the Miller Building is the Kruse Bicycle Shop, which is the current location of De La Vega's Restaurant. Kruse operated his bicycle shop for many years, working on bikes and motorcycles. His bike shop moved farther north on Woodland Boulevard in later years. The white building to the right is the J.F. Allen & Co. building, built in 1887; it housed a furniture store and funeral home. This building was torn down and replaced by other structures in the 1920s.

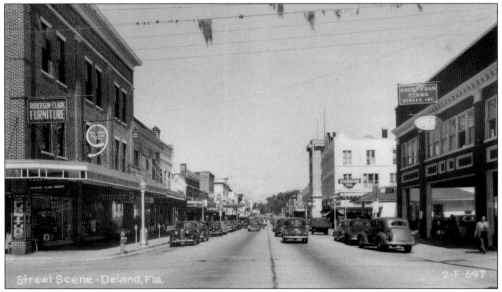

STREET SCENE. This is another view looking north on Woodland Boulevard near the intersection with West Georgia Avenue (called Short Street at that time) taken during the 1940s. Acree Motor Company at 119 South Woodland Boulevard (far right) was a Ford and Goodyear Tire dealer, and the Roberson-Clark Furniture Store at 120 (far left) opened about 1935 and stayed in business as Clark Furniture until the 1990s. The Acree building and the Standard Oil gas station to the north were demolished, replaced by parking lots today.

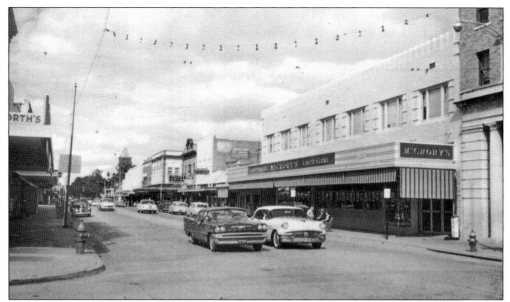

MAIN STREET, LOOKING NORTH. This 1950s view of downtown DeLand was taken from the southwest corner of Woodland Boulevard and New York Avenue. The J.G. McCrory Co. was located at 103–107 North Woodland Boulevard (right), and the F.W. Woolworths awning at 100 Woodland Boulevard can be seen on the left. Both stores had lunch counters and remained open for business until about 1985. Cook's Café and Coffee Bistro are located in the old McCrory's building today along with a number of other specialty stores. (Author's collection.)

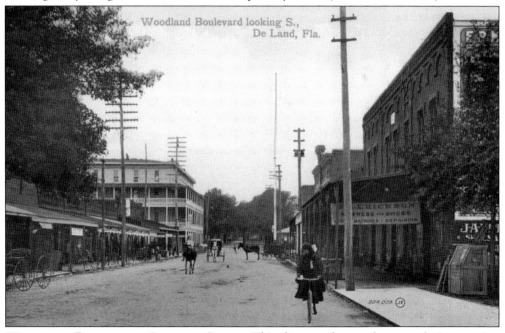

WOODLAND BOULEVARD, LOOKING SOUTH. This photograph was taken near the intersection of Woodland Boulevard and Indiana Avenue prior to 1909, when the Dreka Building was still a wood-frame structure. The early power poles are visible along with the Erickson Harness and Shoe shop on the right.

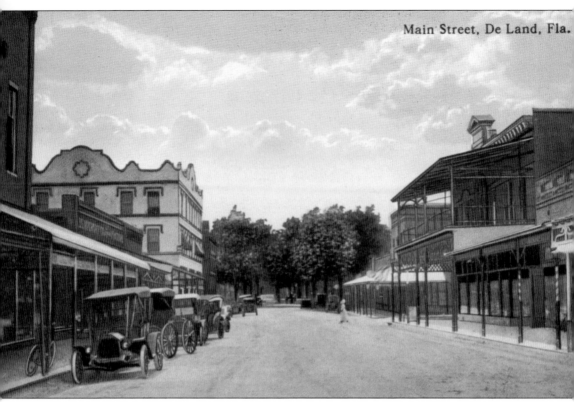

MAIN STREET. Based on the automobiles parked along the road, this view of Woodland Boulevard dates to the 1910s. Looking south, the new Dreka Building at the corner of New York Avenue is visible on the left, as is the Miller Building, which would be purchased by Bert Fish in 1925 for $150,000.

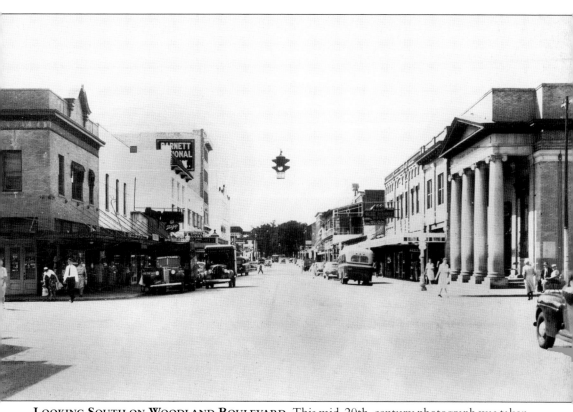

LOOKING SOUTH ON WOODLAND BOULEVARD. This mid-20th-century photograph was taken just north of the intersection of Woodland Boulevard and Indiana Avenue. The old Volusia County Bank building is on the right, and the Barnett Bank building can be seen in the distance.

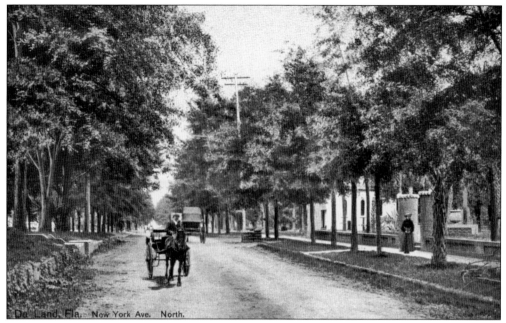

"DE LAND, FLA. NEW YORK AVE. NORTH." Curiously, New York Avenue is an east–west road, and this view is looking northwest toward St. Peter's Catholic Church, near the intersection with Delaware Avenue. Since the church rectory is not visible, this photograph was taken prior to 1906 but may have been used for many years afterwards.

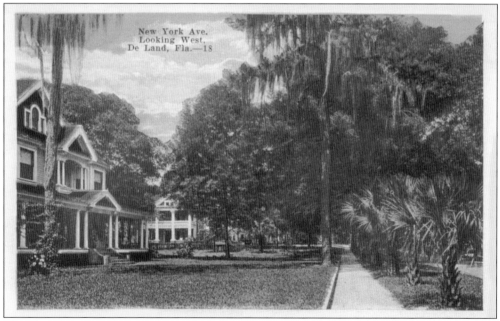

NEW YORK AVENUE, LOOKING WEST. This view of the historic homes that lined the street is a thing of the past. While some historic homes remain scattered along the west side of New York Avenue, the largest and most stately have been lost to time, with the exception of the John Wesley Dutton House at 332 West New York Avenue. It is in the process of being restored with grant funds and donations.

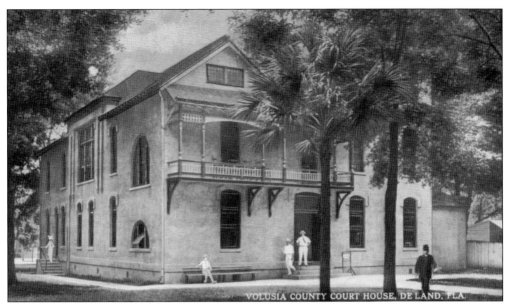

VOLUSIA COUNTY COURTHOUSE. This courthouse was built in DeLand about 1889 after the county seat was relocated from Enterprise in 1888. It was approximately across the street from where the sheriff's office and jail were located on New York Avenue and was demolished in 1927. Lake Helen resident John Porter Mace, who also built DeLand Hall and Stetson Hall for the university, was the architect. (Author's collection.)

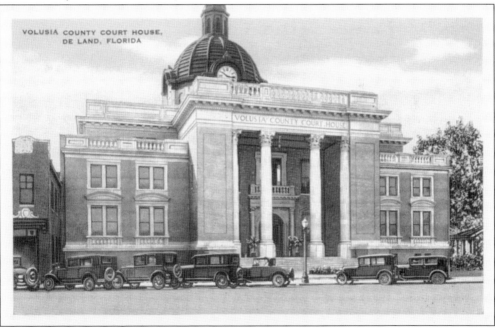

SECOND VOLUSIA COUNTY COURTHOUSE. Construction of the second courthouse building in DeLand was started in 1927 in the same spot where the first courthouse was torn down. It opened its doors in 1929. It has entrances on both West New York and Indiana Avenues. The third courthouse was opened in 2001, but this classic structure is still used by the county for meeting and office space and is home to the Jackson Walker Legendary Florida art exhibition.

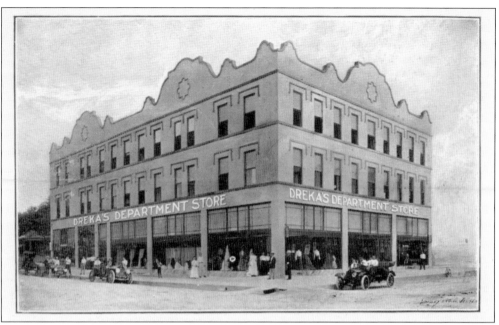

DREKA'S DEPARTMENT STORE. George Dreka established his department store in 1878, adding to and remodeling the building a number of times before it took on its final form, seen in this 1920s postcard. The old wooden four-story structure, which had his storefront on the bottom two floors and the Carrolton Hotel on the top two floors, was moved south to make room for the construction of this building in 1910. (Author's collection.)

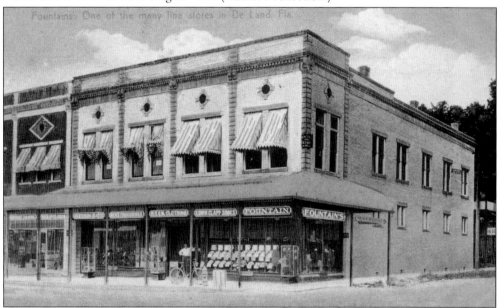

FOUNTAIN'S. Located at 129 North Woodland Boulevard on the northeast corner of Indiana Avenue and Woodland Boulevard, Fountain's was in direct competition with Dreka's one block to the south. Victor M. Fountain started his career at Dreka's as head clerk prior to opening his own store. It was the first retail outlet for Stetson hats in Florida. This building was built in 1907 and is the current home of Stetson Flower and Wedding Boutique.

DELAND DAILY NEWS. This building, constructed in 1903, is located at 109 West Rich Avenue and still stands today. The postcard says it is the modern home of DeLand's progressive daily newspaper, a member of the Associated Press. The *DeLand Daily News* was started about 1900 as a supplement to the *DeLand Weekly News*, which was known originally as the *Orange Ridge Echo* owned by Henry DeLand. Initially, the daily paper was about four pages long and was printed only during the winter season. (Author's collection.)

BRILL'S. Located at 113 North Woodland Boulevard, F.G. Brill's Novelty Shop was a novelty and gift store and would have carried souvenirs from DeLand. This "undivided back" postcard would have been printed prior to March 1907. Presumably Frank Brill is pictured in front of his store, which has a large number of postcards hanging in the window. This building, which dates to 1887, was replaced in 1925 and is the current location of Pretty Little Things Boutique. (Author's collection.)

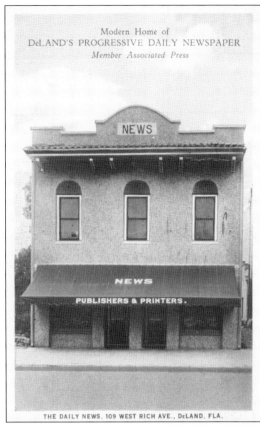

Modern Home of
DeLAND'S PROGRESSIVE DAILY NEWSPAPER
Member Associated Press

THE DAILY NEWS, 109 WEST RICH AVE., DeLAND, FLA.

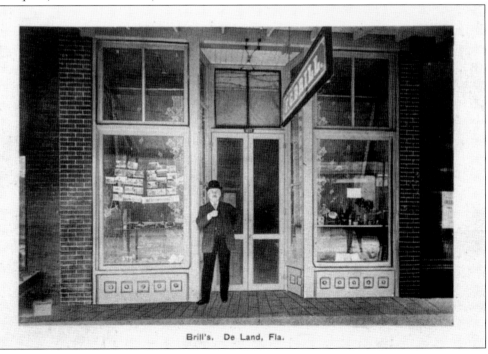

Brill's. De Land, Fla.

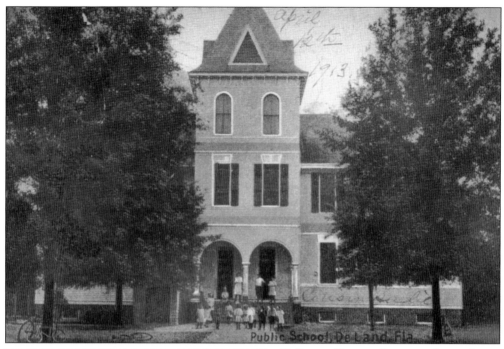

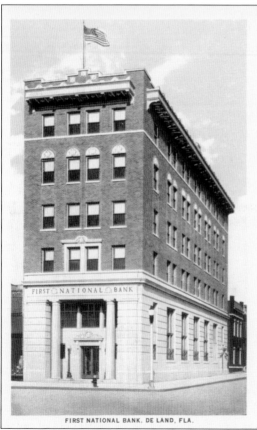

FIRST NATIONAL BANK. DE LAND, FLA.

DeLand Public School. Located at the southwest corner of Rich and Clara Avenues, the school was erected in 1898–1899 at a cost of $12,000. A new wing was added in 1907 with funds raised by the Ladies Home Improvement Society and money donated by Elizabeth Stetson in addition to money from the school board and the City of DeLand. That same year, the school had 10 grades and eight teachers.

First National Bank of DeLand. This building was completed in 1898, and at the time, was the tallest structure in DeLand. The bank fell victim to the Great Depression, but the building became the home of Barnett Bank in the 1930s. Located at the northeast corner of Woodland Boulevard and New York Avenue, it is home to the Baumgartner Company today.

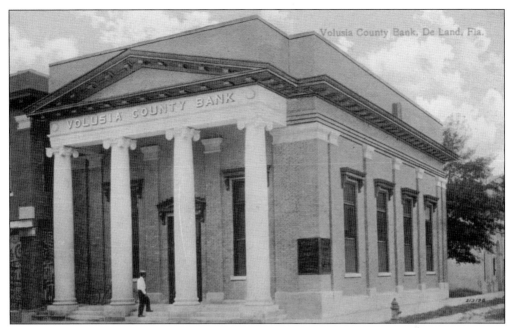

VOLUSIA COUNTY BANK. The Volusia County Bank and Trust opened in 1889 and served DeLand customers for about 40 years before falling victim to the Great Depression and closing its doors July 10, 1929. The First State Bank of DeLand opened in this same building in 1935, and in 1948, the name was changed to Florida Bank at DeLand. This building, erected in 1909, still stands on the southwest corner of Indiana Avenue and Woodland Boulevard and is home to Insurance Land and Manzanos Deli today.

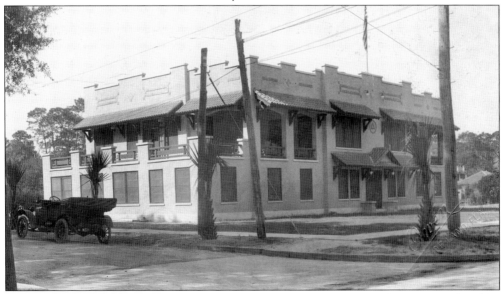

DELAND COMMERCIAL CLUB. The club was officially chartered on March 27, 1916. A bond for $12,000 was floated until the construction was fully completed in 1918. Earl W. Brown, who would later serve as mayor of DeLand, was appointed secretary in 1917. The building was located on the southwest corner of New York and Florida Avenues, housing the DeLand Chamber of Commerce and a tourist club. It maintained a travel bureau and issued brochures touting the benefits of DeLand.

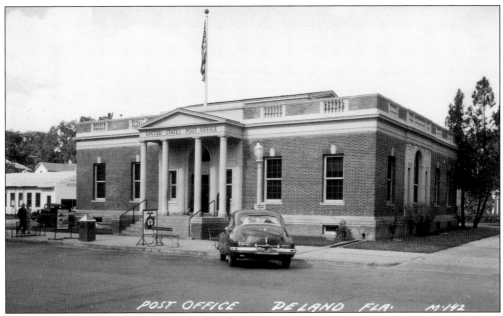

POST OFFICE. The DeLand Post Office, built in 1916 on the northeast corner of Indiana and Florida Avenues, was open from 8:00 a.m. to 6:00 p.m. for general delivery. The postmaster at that time was Edward L. Powe. In 1987, it was demolished along with the old jail from the late 19th century to make room for the new county administration building.

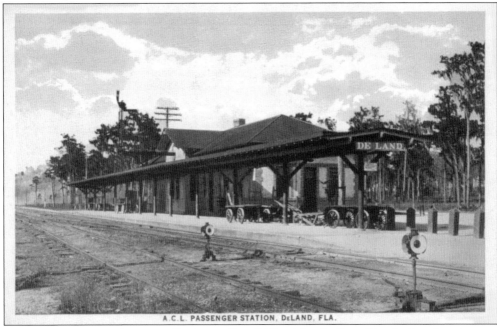

"A.C.L. PASSENGER STATION, DeLAND, FLA." The Atlantic Coast Line Railroad station was built in 1918 on old New York Avenue about seven miles west of town. This building at 2491 Old New York Avenue still stands and serves as the local Amtrak passenger station. This station will be expanded and updated in 2014 as part of the SunRail line, connecting Kissimme with DeLand and ultimately stretching to Tampa and Daytona Beach.

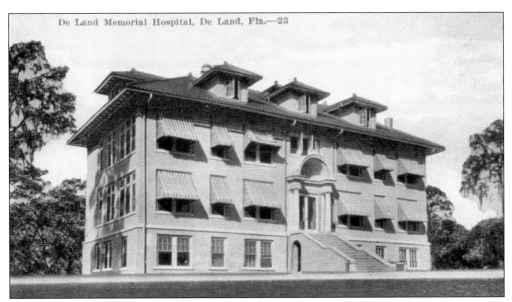

DeLand Memorial Hospital. The hospital on Rich Avenue prior to the opening of this structure was called St. Luke's. Later called DeLand Memorial, this hospital was completed in 1922 and dedicated to the servicemen of World War I. Located at 230 North Stone Street, this 20-bed facility with four private rooms provided a facility greatly needed for a population rapidly growing with the land boom. Guests of the College Arms Hotel furnished the choicest of the private rooms. At the time it opened, it cost $6 a day to be admitted. This facility was used until after World War II, when the hospital was moved to the Naval Airbase facility prior to the opening of Fish Memorial in 1952. Today, the refurbished building contains city offices, and the second and third floors are home to the DeLand Memorial Hospital Museum.

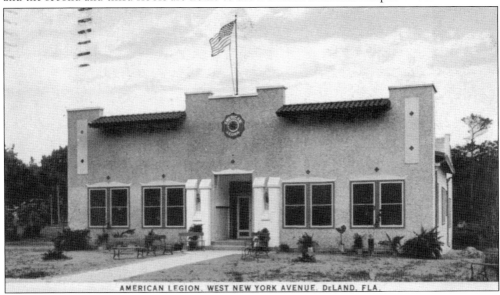

AMERICAN LEGION, WEST NEW YORK AVENUE, DeLAND, FLA.

Legion. This building was located at 220 West New York Avenue. It was built sometime between 1922 and 1924 and was the home of the American Legion, a service organization chartered and incorporated by Congress in 1919. This building was roughly located where the present-day city hall stands across the street from the Putnam Hotel.

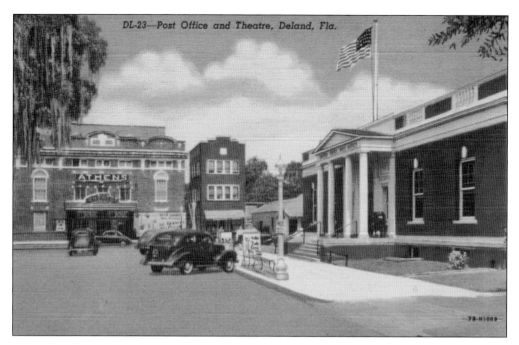

DL-23—Post Office and Theatre, Deland, Fla.

ATHENS THEATER. The Athens Theater, designed by Orlando architect Murray S. King, opened its doors January 6, 1922. Originally it was a vaudeville house, featuring live performances and a silent movie theater. The second view depicts the theater in the 1950s. When the theater closed its doors, it was in severe disrepair and had been serving food and alcohol during the movies. Mainstreet DeLand spearheaded a restoration effort around 1993 that resulted in the doors reopening to a fully-restored structure, looking much like it did when it first opened. As with many of the old buildings in DeLand, ghost stories abound about this downtown gem.

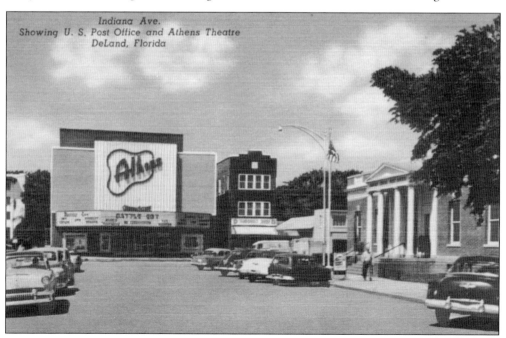

Indiana Ave.
Showing U. S. Post Office and Athens Theatre
DeLand, Florida

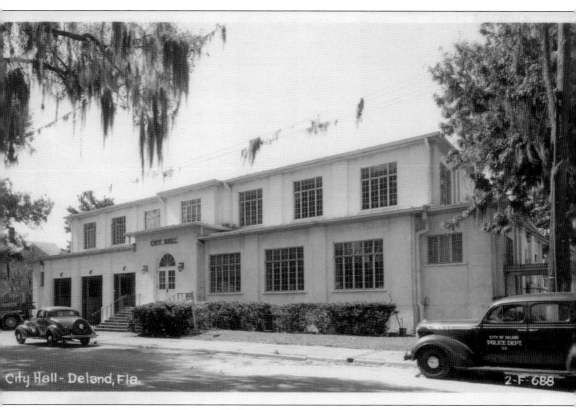

CITY HALL. The DeLand City Hall, built in 1926, was located at 118 South Florida Avenue near the southwest corner of New York and Florida Avenues but was demolished in January 2007 to make room for parking at the new City Hall. It was designed by famed local architect Medwin Peek, a Stetson and Harvard graduate and childhood friend of Bert Fish. This structure sat closer to the street than the new building and the open garage bay doors seen here fronted Florida Avenue and housed DeLand's only fire department at that time.

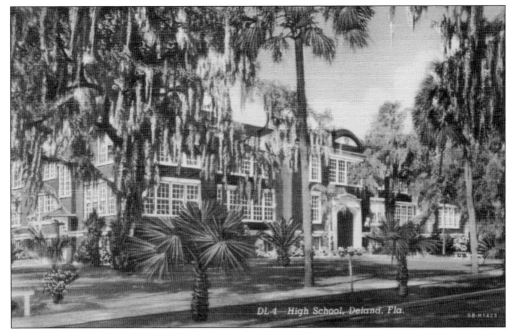

HIGH SCHOOL. The DeLand High brick structure was erected in 1917 when the grade school and high school classes grew so large they needed to be housed in separate buildings. Located at the northwest corner of Clara and Rich Avenues, this building burned in 1979, and the site was used to build the new school board administrative center. (Author's collection.)

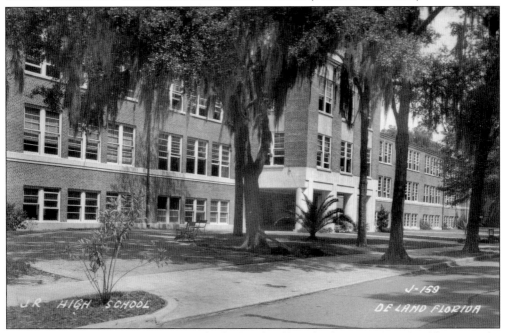

"JR HIGH SCHOOL." An annex to the high school was built in 1939 as an addition to the 1917 brick high school structure. After the new high school was built at Plymouth and Hill Avenues in 1961, the entire facility was taken over by DeLand Junior High in January 1962. (Author's collection.)

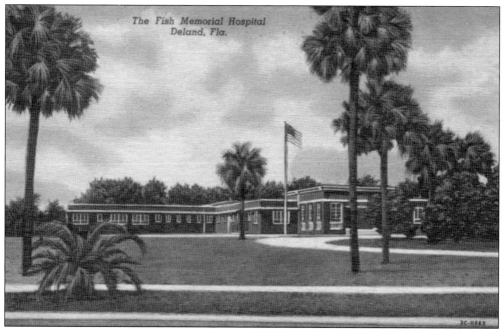

THE FISH MEMORIAL HOSPITAL. This hospital, located at 245 East New York Avenue, occupied the spot where the College Arms Hotel was located. Construction of the original 50-bed Fish Hospital began in July 1951. It opened the following September. Known for its "family atmosphere," it closed September 1994 when patients were transferred to the new Fish Memorial Hospital in Orange City. Bert Fish was the first graduate of Stetson University College of Law and was a prominent attorney and politician. He died in Portugal in 1943 while serving as ambassador under Pres. Franklin D. Roosevelt, leaving his entire estate in a charitable trust fund to build and support hospitals in the area. (Author's collection.)

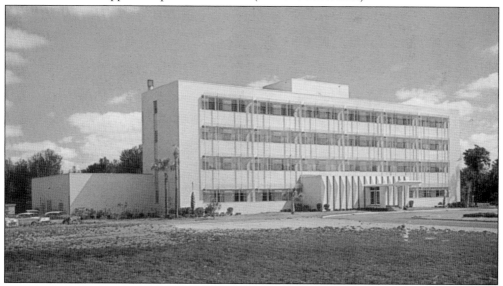

WEST VOLUSIA MEMORIAL HOSPITAL. Now called Florida Hospital DeLand, the hospital celebrated 50 years in October 2012. Artist Louis Freund's mural depicting medical care through the ages adorns the entrance to the hospital. (Author's collection.)

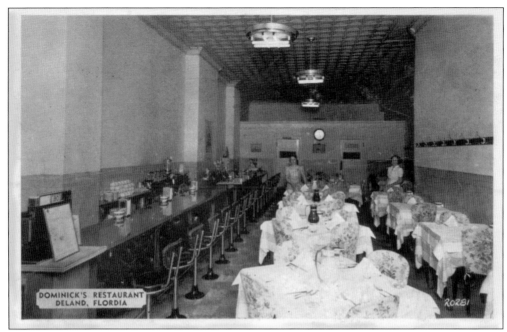

DOMINICK'S RESTAURANT. Owned by Dominick "Jimmie" Vitsaras, a Greek immigrant, Dominick's operated for many years at 202 North Woodland Boulevard, serving family-style specialties. It was a family-favorite diner from 1934 until the early 1980s, when it closed. Hunter's Restaurant, another longtime favorite, is located at 202 North Boulevard today.

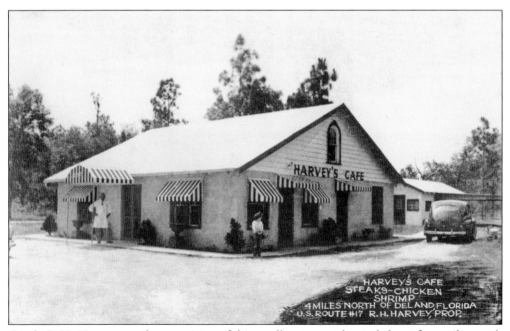

CAFÉ. R.H. Harvey was the proprietor of this small restaurant located about four miles north of DeLand on US Highway 17. It was well known for its steaks, chicken, and shrimp.

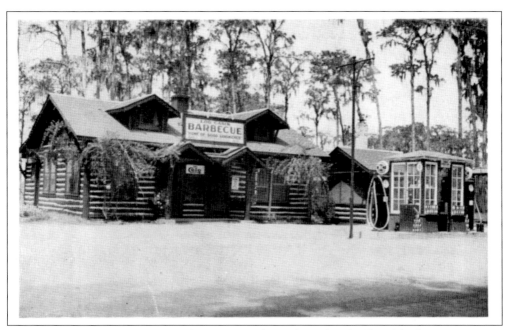

THE LOG CABIN BARBECUE. The "Home of Good Sandwiches" and barbecue was open 24 hours a day. It operated from the 1930s through the early 1980s at 1330 North Woodland Boulevard. Later, a number of steak and Mexican restaurants have operated in this location, but none have had the staying power of the Log Cabin! Note the fuel "island" and pumps in front of the restaurant to the right.

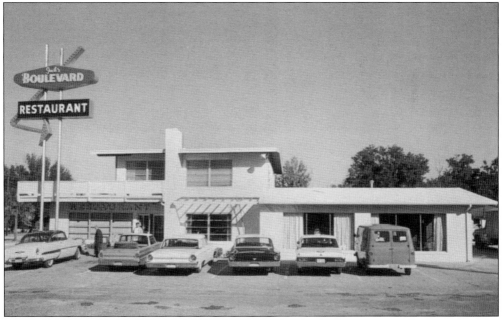

JACK'S BOULEVARD RESTAURANT. Owned and operated by Jack and Pauline Perkins, the restaurant offered very good food at moderate prices and specialized in steaks charbroiled and cut to order. This building is located at 1329 North Woodland Boulevard and is the current home of Won Lees Chinese Restaurant, whose billboard tells everyone to "have a rice day."

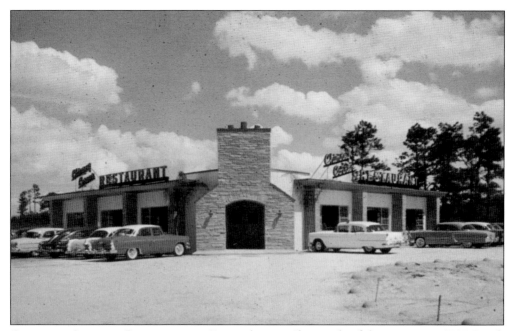

CHIMNEY CORNER RESTAURANT. Located two miles south of downtown at 1727 South Woodland Boulevard, this restaurant opened in the 1950s. It was located next to the Chimney Corners Hotel. The restaurant burned down in late 1960s or early 1970s, but the hotel is still in operation.

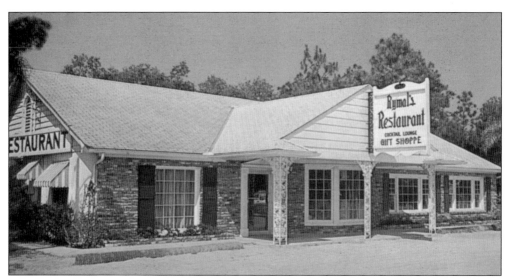

RYMAL'S RESTAURANT. Rymal's had a cocktail lounge and gift shop and specialized in buffet dinners, pastries, and homemade dinners in a quiet atmosphere. The building, located at 3520 North US Highway 17 between DeLand and Deleon Springs, stands vacant today and is located just north of the Blessing Motel.

ALLEN-SUMMERHILL FUNERAL HOME. Founded in 1877 as J.F. Allen & Co., Funeral Directors and Practical Embalmers, Allen-Summerhill Funeral Home is one of the oldest and longest continuously operating funeral homes in Volusia County. Allen was one of the pioneer settlers in DeLand and a member of the Old Settlers Society. The current business is comprised of three buildings at 126 East New York Avenue, with the oldest having been constructed in 1902.

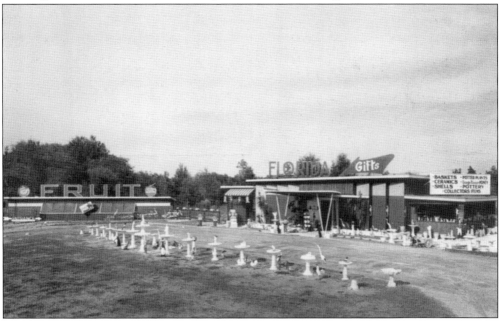

FLORIDA GIFTS. Owned by Roger and Doreen Alling, this so-called tourist attraction was located at 1625 South Woodland Boulevard, about two miles south of DeLand. They offered Florida oranges and other fruit along with pottery and roadside collectibles such as travel decals, key chains, and commemorative spoons.

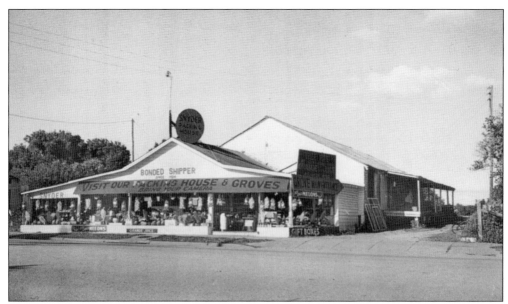

SNYDER PACKING HOUSE. Snyder's opened in 1934 and specialized in gift boxes of Volusia and Indian River fruit. In the 1940s and 1950s, a 90-pound box of fruit cost about $9. They would fresh squeeze juice while patrons waited. They also sold melons, jellies, and candies. This building was located at 1509 North Woodland Boulevard, which is near the present-day intersection of Woodland and International Speedway Boulevard (US 92).

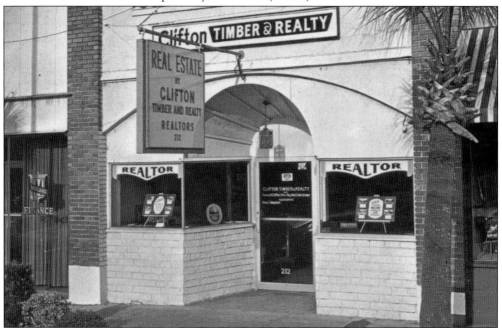

CLIFTON TIMBER AND REALTY COMPANY. Francis H. Clifton, a realtor and registered forester, owned Clifton Timber and Realty Company, located at 212 North Woodland Boulevard. His family members were early settlers of West Volusia County. Opening his business in 1958, Clifton advertised that he would buy and log timber in addition to standard realtor services. Currently, Groovy Records is located in this building.

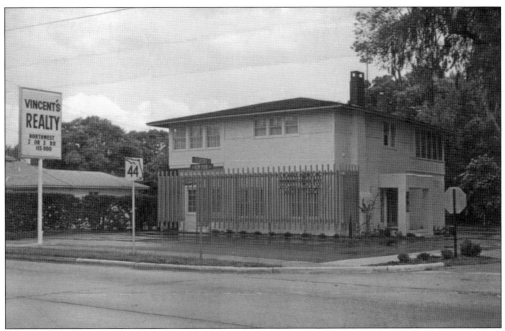

VINCENT'S REALTY AND GOULD REAL ESTATE INC. Vincent's Realty, owned by Vincent W. Gould III, was located at 824 West New York Avenue. Gould Real Estate Inc., owned by William H. Gould, was located at 300 North Woodland Boulevard in the old First Christian Church building. Both men are the grandsons of the founder of the family business, Vincent Ward Gould, who moved to DeLand in 1885 from Saginaw, Michigan. He started his real estate and insurance business in 1907 on East Indiana Avenue but moved to the current location at 201 North Woodland Boulevard in 1940. The insurance portion of the business stayed at this address, but the real estate portion moved and then returned.

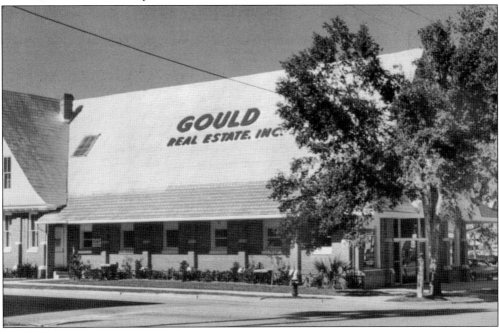

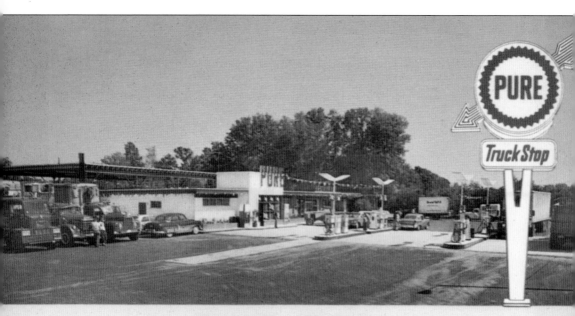

LEVEILLE'S BIG RIG TRUCKSTOP
15A BY-PASS • DE LAND, FLORIDA

"LeVeille's Big Rig Truckstop." Bill Leveille built his truck stop at 833 North Spring Garden Avenue on the southeast corner with Plymouth Avenue in 1962. It was an early truck stop that offered Pure Oil products, a restaurant, roomettes, and showers for hungry truckers traveling between Jacksonville and Orlando. Leveille's "Got Grits?" sign also attracted local fishermen and hunters who became regulars at the 24-hour restaurant. The Rig was torn down a few years ago, but the Big Rig Two is located just west at 815 North Spring Garden Avenue.

INLAND BUICK COMPANY. This postcard is an advertisement for the new Air Born B-5B Buick. Inland Ford, located at 117 East New York Avenue, produced this promotional postcard. Today, that location is a City of DeLand parking lot that has been the home to Rufus Pinkney's Deluxe Shoe Shine Parlor since 1970. Pinkney has been shining shoes since the early 1940s when he got his start at a barbershop in Palatka. He moved to DeLand in the 1950s.

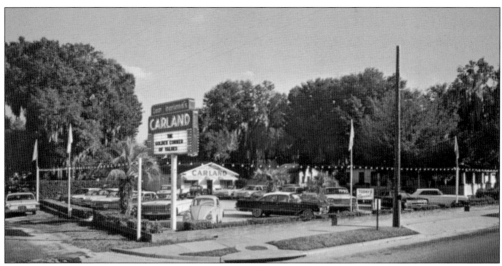

CARLAND. Tom Harland's Carland was located at 1117 North Woodland Boulevard at the intersection with Kensington Road. Harland billed himself as "Volusia's oldest independent auto dealer" and came up with slogans like the "Golden Corner of Values." Anything on Wheels currently occupies this site.

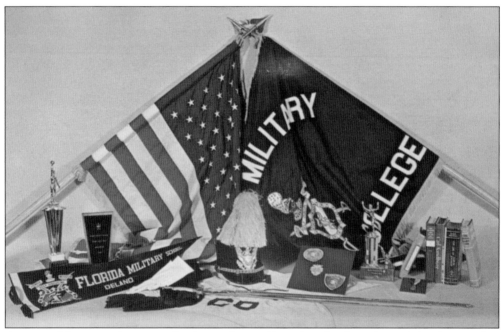

FLORIDA MILITARY SCHOOL. On September 4, 1956, the Florida Military School opened its doors to 63 cadets and was the "Home of Scholarly Gentlemen" from that time to 1971. Col. Carl Ward started the school at the old DeLand Naval Air Station facility (today the DeLand Airport) in the converted World War II infirmary. The old Officers Club was converted for use as the school's mess hall. There were five graduating seniors the first year. Although none of the buildings remain standing, alumni still gather for class reunions in DeLand to reminisce and celebrate their days at the school.

Four

HOUSES OF WORSHIP

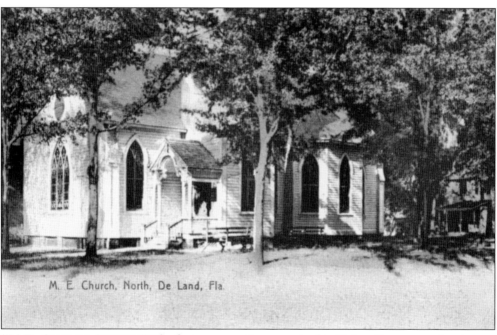

M. E. Church, North, De Land, Fla.

"M.E. CHURCH, NORTH." The first congregation organized in DeLand began meeting August 1, 1880, though many of its early members along with those of the Baptist church held outdoor services together. Rev. Menzo Smith Leete, pioneer preacher of DeLand, preached the first of such services, and he and Reverend Mehan held a joint service for about 70 when the joint schoolhouse and church building were completed in March 1877. This building was paid for in part by funds gathered by Hettie Austin.

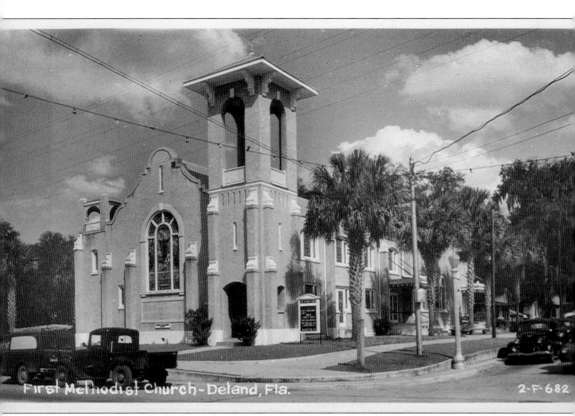

First Methodist Church-Deland, Fla. 2-F-682

FIRST METHODIST CHURCH. This first Methodist congregation met in homes and other buildings until their first building, also paid for with funds raised by "Aunt Hettie," was completed February 23, 1883. It was built on the corner of Woodland Boulevard and Howry Avenue on land donated by J.W. Howry. By 1919, a new, larger building was needed. Bishop Frederick DeLand Leete and Charlotte Glover worked with members to raise funds. The old wooden structure was pushed back off Woodland Boulevard and turned to make room for the new Spanish Revival–style sanctuary.

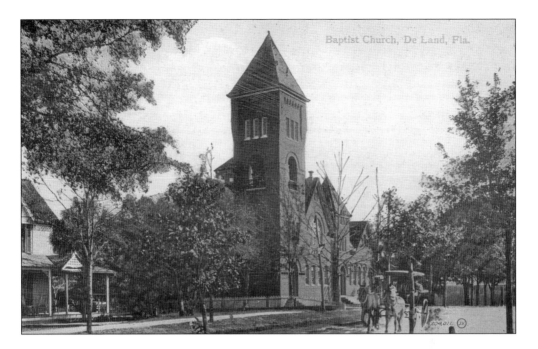

FIRST BAPTIST CHURCH. This congregation, the second organized in DeLand, formed October 31, 1880, with 30 members. Like the Methodists, they met outdoors and shared the school building until their first building was dedicated April 16, 1882, on land donated by Henry DeLand on Rich Avenue near Woodland Boulevard. In 1895, the church constructed a much larger brick structure and added a two-story educational building in 1950. It moved farther north on Woodland Boulevard to its present building in 1960.

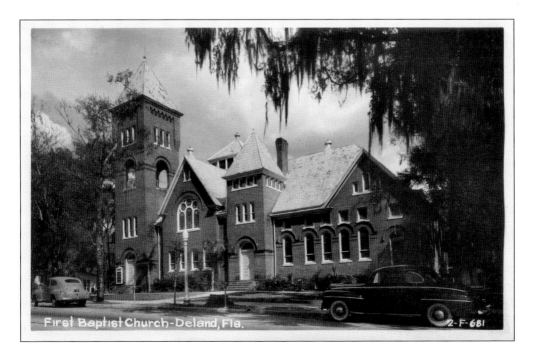

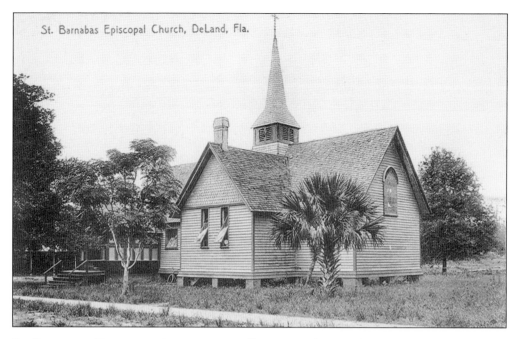

St. Barnabas Episcopal Church, DeLand, Fla.

ST. BARNABAS EPISCOPAL CHURCH. Formally organized September 24, 1882, when the Rev. Robert Wolseley summoned all Episcopalians in the vicinity of DeLand to meet in the first schoolhouse. John Rich donated the land at the northwest corner of West Wisconsin and Clara Avenues for the first building. Richard Upjohn designed the Carpenter Gothic structure after a little church in England. This style influenced many churches throughout Florida and the country. Construction started in November 1883 and was completed under the supervision of Reverends Wolseley and Bielby on Easter Day 1884. J&R Lamb did most of the stained-glass windows, but at least one is a Tiffany.

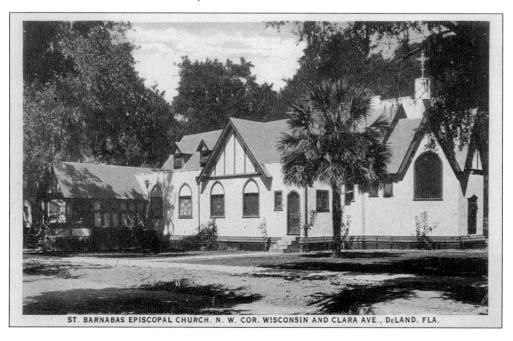

ST. BARNABAS EPISCOPAL CHURCH, N. W. COR. WISCONSIN AND CLARA AVE., DeLAND, FLA.

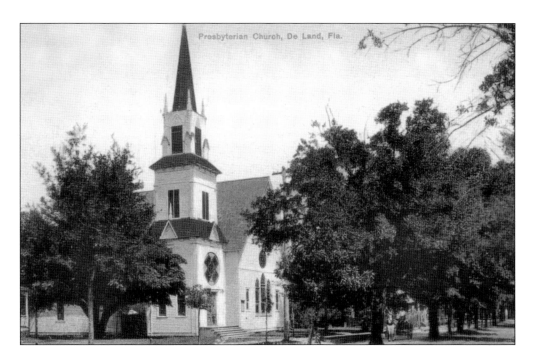

PRESBYTERIAN CHURCH. The Rev. Gilbert Gordon organized the First Presbyterian Church in 1882 with 24 charter members. Like all the other early churches, they first met in a member's home, like that of Mr. and Mrs. W.W. Cleaveland, then the schoolhouse, and finally, the First Methodist Church. A lot at 234 North Woodland Boulevard was purchased, and the building was dedicated in March 1890. A new location was selected farther north on Woodland Boulevard in 1947 where the current building is located.

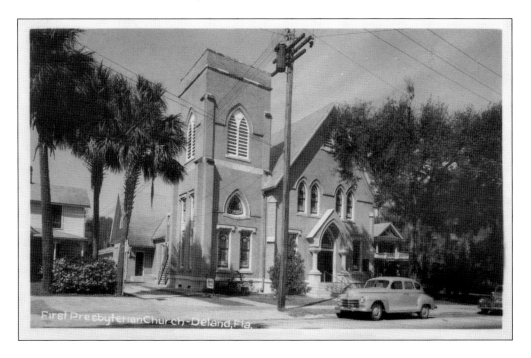

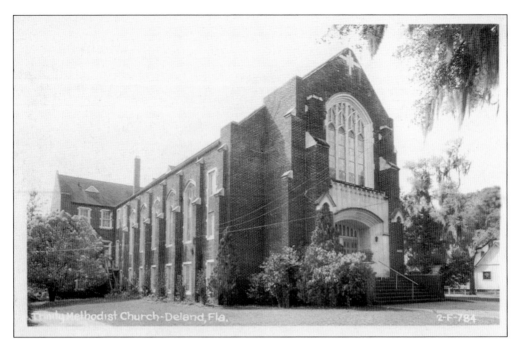

TRINITY METHODIST CHURCH. This church started in 1895 as the First Methodist Episcopal Church South, served by circuit-rider preachers of the Volusia circuit. They met first in the old DeLand City Hall and then in the old schoolhouse until purchasing the old First Baptist Church on East Rich Avenue for $1,000. The first pastor was Rev. Joseph Bell, one of the circuit preachers. In 1905, the name was changed to Grace Methodist but then changed back to the original name in the early 1920s. The current structure was built in 1925 at the southwest corner of North Clara and West Wisconsin Avenues.

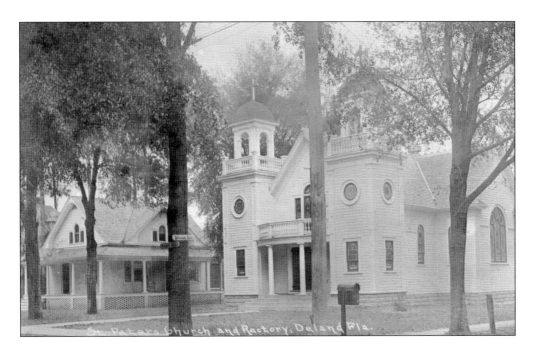

ST. PETER'S CHURCH AND RECTORY. Fr. William J. Kenny celebrated the first Mass in the new chapel on April 19, 1884. The Kilkoff, Dreka, Ziegler, and Fisher families were the first parishioners. Two acres of land bordering West New York, Delaware, and Rich Avenues were donated by John and Clara Rich with the condition that it revert back to them or their heirs if a cemetery was started on the property. The first resident pastor was Michael J. Curley from Ireland in November 1904. He built the rectory in 1906, and the church was moved and enlarged in 1910. The current building was erected and then dedicated on December 18, 1960.

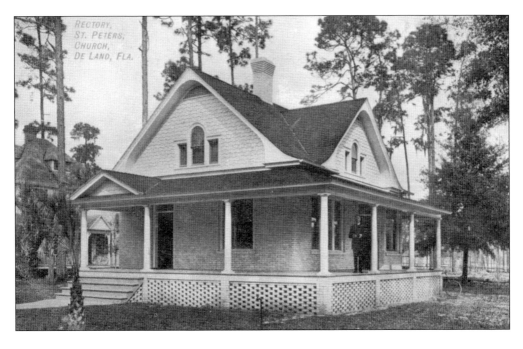

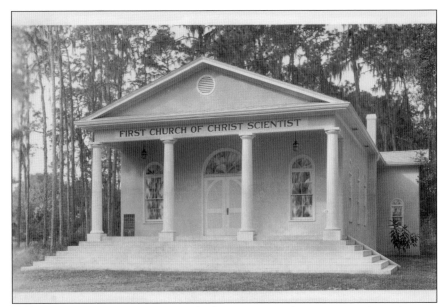

FIRST CHURCH OF CHRIST SCIENTIST. The first services and organizational meetings were held in the nine charter members' homes. They were the Falks, Sadie Hiseradt, Mary Mitchell, Jessie Mitchell, Mathilde Power, Mr. and Mrs. Silas Wright, and Mrs. C.A. Standbrook. The Ruff property on South Clara Avenue was purchased in 1923, and a building was started in February 1929 and completed in May of that year. In 1963, the reading room was moved to an independent downtown location at 111 West Indiana Avenue and then to 111 East New York Avenue in 1973.

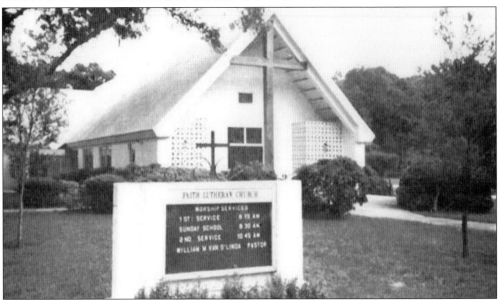

FAITH EVANGELICAL LUTHERAN CHURCH. Faith Evangelical is located at 509 East Pennsylvania Avenue. The sanctuary was built in 1953, but the history of the Lutheran Church in DeLand goes back to the turn of the 20th century, when Ed Fisher, pastor of Ebenezer Lutheran in Pierson, held services in DeLand. In the 1940s, members of what would become Faith met in the Women's Club, and on April 22, 1951, seventy-six members and children led by Rev. Glen Pierson signed the Charter Role to officially organize the church. (Author's collection.)

Five

HOME SWEET HOME

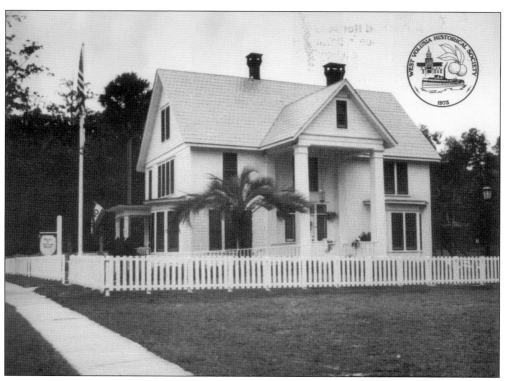

HENRY A. DELAND HOUSE. According to some sources, this is one of two homes Henry DeLand had built in the 100 block of Michigan Avenue. Believed to have been built in the mid-1880s, this home would have been small compared to some of the other DeLand building projects, but Henry Deland was already beginning to experience a downturn in his financial standing at this point. This house still stands and serves as the Henry A. DeLand House Museum and home of the West Volusia Historical Society. (Author's collection.)

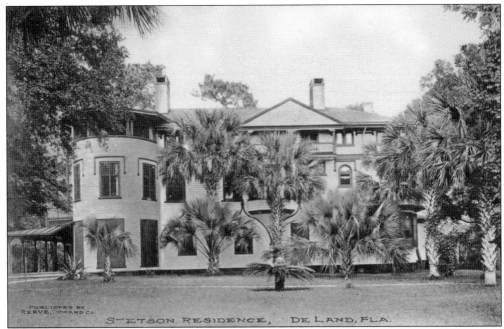

STETSON RESIDENCE. The John B. Stetson home was built on Camphor Lane just east of Spring Garden Avenue. He purchased the 300-acre tract of land from Dr. H.H. Gillen, from whom he took the name of his estate, "Gillen." The home was built in 1886 with lumber milled in Pennsylvania and shipped to Florida by Clyde Steam Line steamboats. The finest craftsmen hand-carved much of the exposed wooden detail, the floors were made of mahogany and oak parquet, and all of the windows were leaded glass with many of them early Tiffany stained glass. The home had three floors, with the top floor providing servant's quarters. Stetson had a small schoolhouse built in the back of the house so his children could receive tutoring when there.

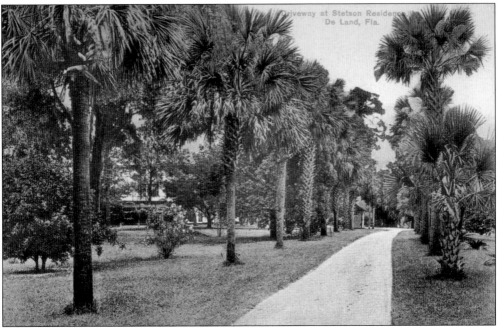

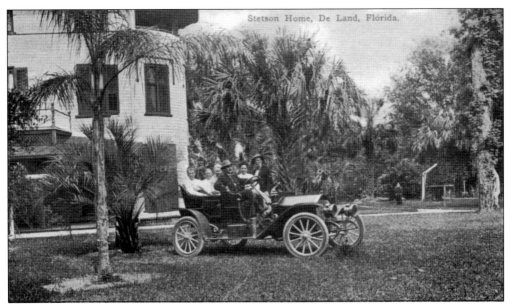

GROUNDS OF THE STETSON HOME. The grounds of the Stetson home were beautifully kept and had wildlife roaming around the large land holdings surrounding it. Stetson built and maintained a fenced alligator pool to the northeast of the house, which is utilized as a retention pond today. Among those pictured here are B.H. Alden and his wife, who lived on the premises as gardener and caretakers when the family went north for the summer.

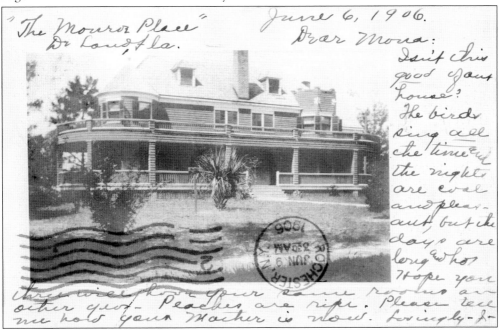

"THE MONROE PLACE." This grand home, built in 1897, was originally located at the southwest corner of Michigan Avenue and Woodland Boulevard. The house was rotated to face Michigan Avenue and moved off the corner for the construction of a gas station in 1932. The home still stands at 122 West Michigan Avenue near Stetson University's president's home, which sits at the northwest corner of Michigan Avenue and Woodland Boulevard.

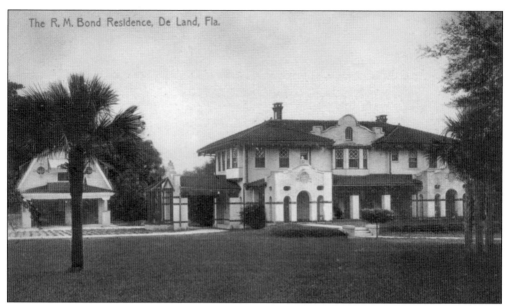

The R. M. Bond Residence, De Land, Fla.

R.M. BOND RESIDENCE. The home of Robert M. and Louise F. Bond was located at 401 West New York Avenue, approximately where St. Peter's Catholic Church is located today at 359 West New York Avenue. On January 6, 1960, Monsignor William Mullally conducted the ground breaking ceremony for the current church located on the northeast corner of Delaware and New York Avenues.

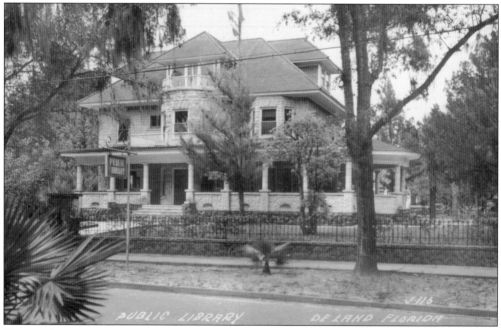

PUBLIC LIBRARY (MCELROY HOME). This building, built in 1895 at the northwest corner of New York and Garfield Avenues, still stands and is used today as a dentist office by Dr. April Flutie. Located at 449 East New York Avenue, the building also served as the DeLand Public Library in the 1940s and 1950s and as the home of the DeLand Museum from 1965 until 1991, when the museum moved to the Cultural Arts Center at 600 North Woodland Boulevard.

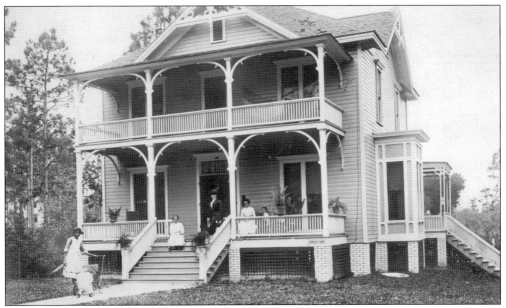

VOORHIS HOME. This home, built in 1883, was originally located near the intersection of Voorhis and Clara Avenues. Dr. Manlius and Mary Adele (Howry) Voorhis were early settlers in DeLand. The home was moved to its current location at the southwest corner of Howry and Florida Avenues. Pictured in this February 1913 postcard are Mrs. Voorhis on the steps, Bob Voorhis with his nurse, Mrs. Greene of Sioux City, Benson, and Grace.

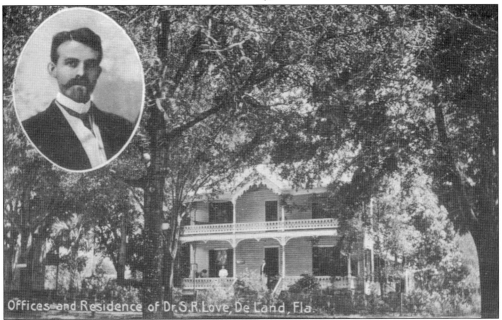

OFFICES AND RESIDENCE OF DR. S.R. LOVE. Dr. Love was an osteopath who wintered in DeLand and returned to Island Park, New York, during the summer months. He received patients in his DeLand office at 8 Pine Street from October to June but declined working with consumptives, today known as tuberculosis. He was married to Grace S. Love and hailed from Pennsylvania. This home still stands on the corner of Pine Street and Plymouth Avenue.

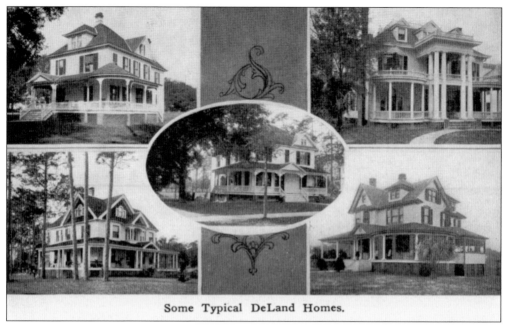

Some Typical DeLand Homes.

"Some Typical DeLand Homes." These magnificent homes were used to advertise the beauty and attractions of DeLand as the Athens of Florida. The upper right home belonged to the Campbell family and was located on the 200 block of East New York Avenue. This view is one of 12 in a postal booklet extolling the virtues of DeLand, mailed in 1908. None of these homes remain standing today.

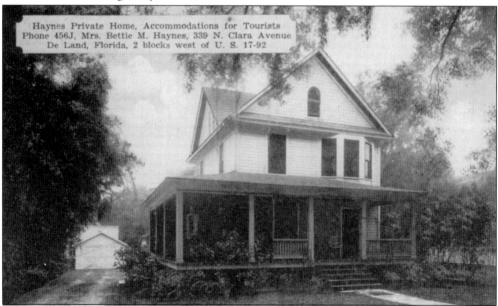

Haynes Private Home, Accommodations for Tourists
Phone 456J, Mrs. Bettie M. Haynes, 339 N. Clara Avenue
De Land, Florida, 2 blocks west of U. S. 17-92

Bettie Haynes Home. This home is located at 339 North Clara Avenue. The house, built in 1914, still stands near the intersection of Michigan Avenue and is across the street from St. Barnabas School. This is one of many Sears, Roebuck & Co. "kit homes" built in DeLand that could be purchased from its catalogue. From 1908 to 1940, Sears sold about 70,000 homes through its mail-order program. Over that time, Sears designed 447 different housing styles.

QUIGLEY HOME. This home was located at 316 North Clara Avenue, but by 1924 was listed at its current address of 416 Clara. It was built in 1895 by James M.A. Quigley from England and his wife Myrtle E. from Ohio. His daughter Martha, born in Australia, moved to Philadelphia and married a wealthy manufacturer named Charles H. Landenberger. She returned to DeLand sometime in the 1950s after her husband died to live in the family home, where she died alone in 2002 at the age of 96. Her estate, worth millions of dollars, was left to Drexel University to fund the Martha Q. Landenberger Research Foundation.

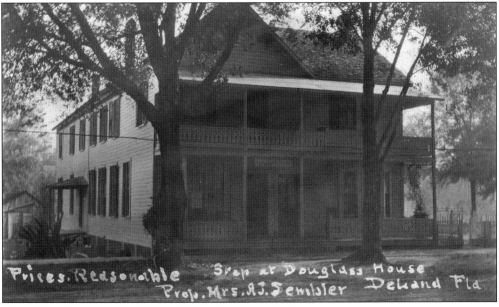

DOUGLASS HOUSE. J.A. Douglass from Tennessee was the proprietor and owner of the Douglass House at the corner of West New York and Florida Avenues. He was also a contractor and builder, and his time spent in this occupation may explain why Mrs. A.J. Sembler was listed as proprietor on this postcard advertisement asking folks to stop at the Douglass House with reasonable prices.

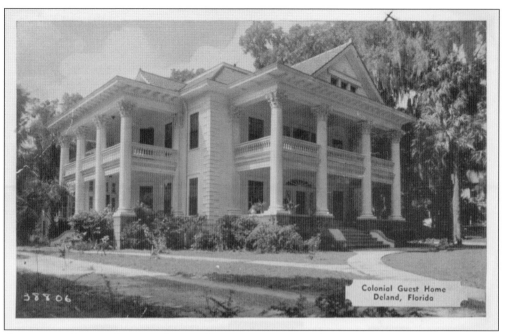

COLONIAL GUEST HOME. John Wesley Dutton, owner of a naval stores company, had this home built in 1910 at a cost of $25,000. He hired the architectural firm of Cairns & Fitcher to draft the plans, and DeLand contractor Gus Lauman supervised its construction. In later years, it was converted to the Colonial Guest Home, which rented rooms to tourists.

WILLIAMS APARTMENTS. This early apartment house was owned, operated, and resided in by realtor Alva C. Williams. It was located at 412 West Howry Avenue. The building is still used as apartments today, but the address changed to 408 when street numbers were modified. Street number changes may have been due to implementation of the 911 emergency call system or parcel subdivision and re-platting.

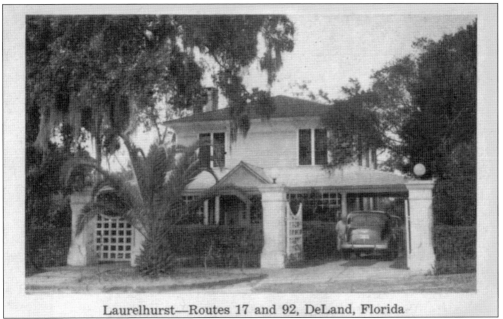

Laurelhurst—Routes 17 and 92, DeLand, Florida

LAURELHURST. This home, built about 1913, belonged to Theodore and Candace Strawn and was located on the northwest corner of North Woodland Boulevard and Plymouth Avenue. The Strawn family owned thousands of acres of citrus groves and the Bob White packing plant in DeLeon Springs. Today, Porkies BBQ at 900 North Woodland Boulevard occupies that corner. The current building was constructed in 1983 and was originally the home of the first 7-Eleven in town.

HARPER HOME. This 1920s home may have belonged to the Harpers who owned Harper's Cafeteria & Grill, which was located at 145–147 North Woodland Boulevard, the current location of the Byte Fragments & Spirits Restaurant. (Author's collection.)

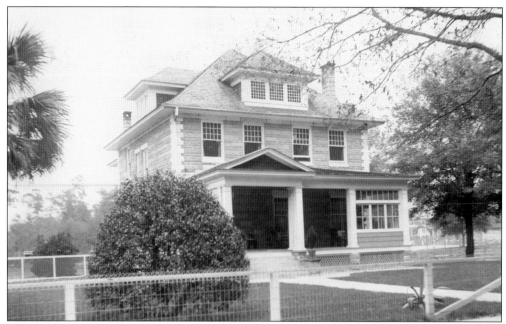

GOLF COURSE HOME. According to the back of this postcard, the sender was boarding at this home, which was located across from the "golf grounds." Likely the reference was to the College Arms Golf Course, which was bounded by East Howry, South Garfield, East Euclid, and South Amelia Avenues. The location of this home is not known.

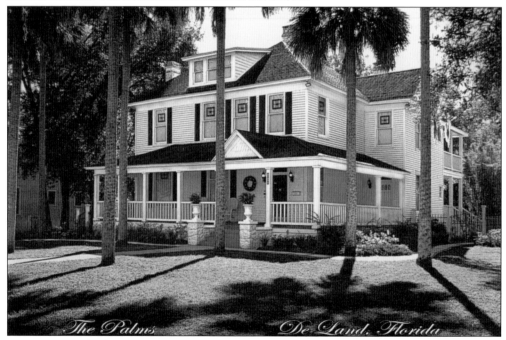

THE PALMS. This home, located at 212 West Minnesota Avenue, was built in 1903. Frederick H. and Kittie Finney owned the home in the 1920s. It was later owned by the Wheeler family and Stetson University and was used as a fraternity house and student housing. It remains one of many stately historic homes along the 200 block of Minnesota Avenue west of Stetson University.

Six

Tin-Can Tourists and Snowbirds

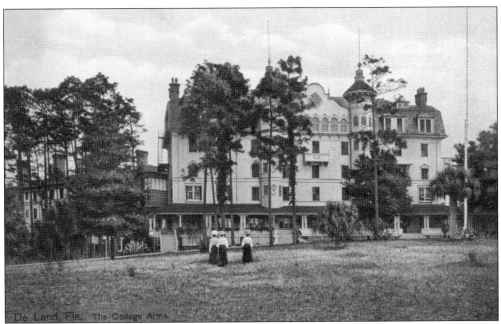

THE COLLEGE ARMS. This grand Victorian hotel run by J.Y. Parce, one of Henry DeLand's brothers-in-law, was enlarged in the early 1880s to create the ParceLand Hotel. John B. Stetson purchased the Parce Land in 1896. The expansion brought the room total to 150 and added many improvements, such as the addition of a nine-hole golf course, later expanded to 18, with a clubhouse and nearby train depot. As a result, the College Arms regularly catered to the rich and famous. Today, the new Volusia County Courthouse, located at 101 North Alabama Avenue, sits where the College Arms was located.

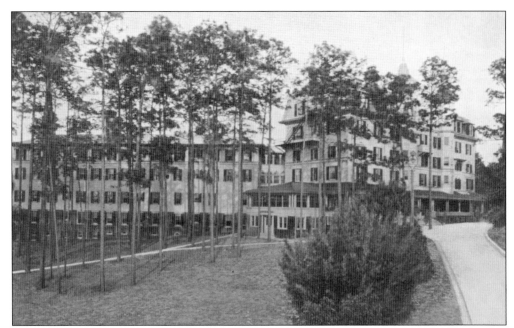

COLLEGE ARMS HOTEL. By World War II its best days were far behind it, but the Navy leased the hotel as an auxiliary for officers from the DeLand Naval Air Station and their families. In the late 1940s, the building was torn down for construction of the Bert Fish Memorial Hospital. The postcard above shows a good view of the main hotel and wing. The driveway to the right intersected with New York Avenue. The postcard below is an extremely rare view of the back of the hotel taken in the early 1900s. The man in white at the top of the steps appears to be one of the hotel chefs.

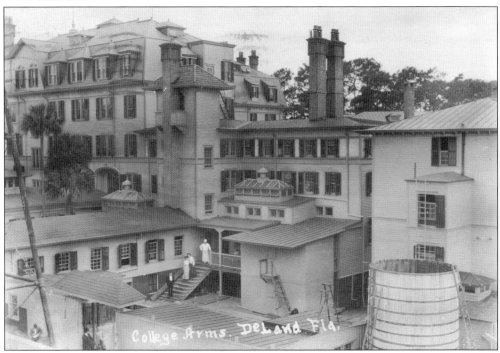

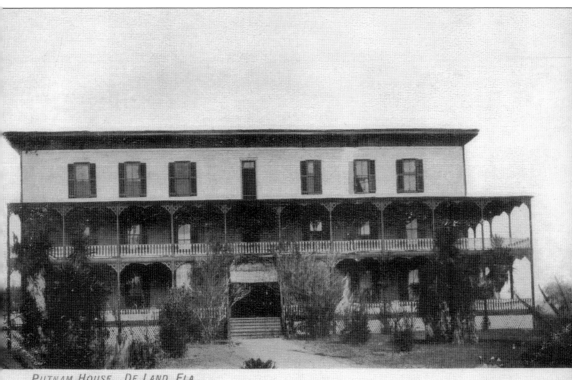

PUTNAM HOUSE, DE LAND, FLA.

E. C. KROPP, PUB. MILWAUKEE, NO. 2975

PUTNAM HOUSE. Henry DeLand sold his interest in the Grove House Hotel to Alfred Putnam, who renamed it the Putnam House. The Putnam House was sold to Gardner Gould around 1889. The Gould family lived in and operated the hotel until they sold it to B.E. Brown in 1896. This original wood-frame building was one of the hotels that Bert Fish called home. This structure burned to the ground on the morning of November 4, 1921.

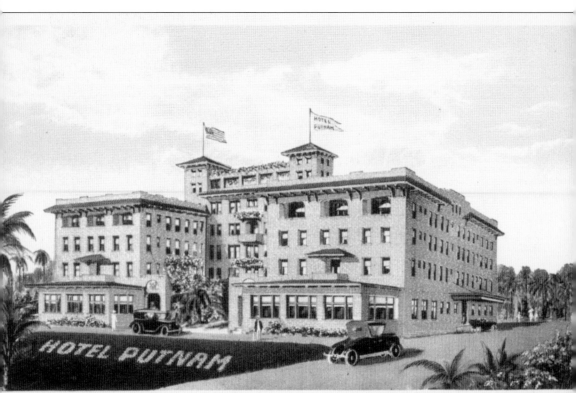

NEW HOTEL PUTNAM, DELAND, FLA. MODERN, FIREPROOF. ONE HUNDRED AND FIFTY ROOMS OF COMFORT.

HOTEL PUTNAM. William. J. Carpenter was contacted and commissioned to design and oversee the construction of a new fireproof building in late 1922. The Putnam was reportedly the first such building in the state. The new 112-room structure cost $433,000 to build and soon occupied a prominent position in the cultural and economic life of DeLand. The Browns sold the hotel in 1959, but it remained in use as a hotel-apartment complex until recently.

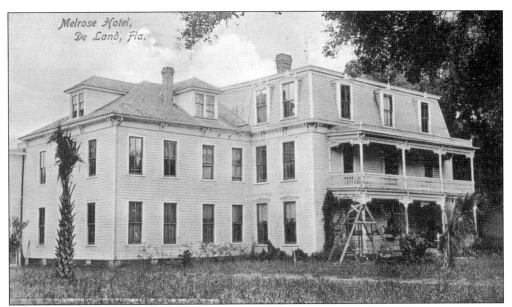

MELROSE HOTEL. In 1907, this hotel was located at 112 East New York Avenue and took private boarders. The photograph dates to about 1909. Just like today, Deland drew many Northern tourists who wanted to escape the cold winters. In 1926, there was a Melrose Inn listed at 211 East Rich Avenue operated by Mrs. M.F. Ouzs.

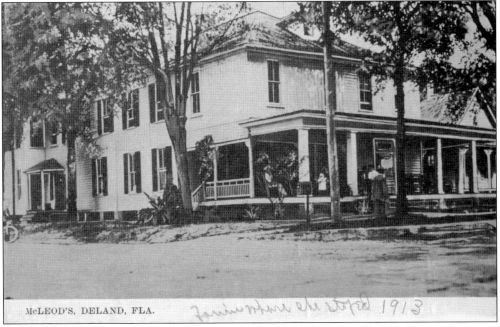

McLEOD'S, DELAND, FLA.

McLEOD'S. McLeod's Boardinghouse was located at 43 West New York Avenue and was run by Mrs. E.D. McLeod, proprietor in 1907. This large home-like hotel had large, sunny rooms, a superior table, and opened its doors to tourists and visitors year-round. Rooms were $2 a day or $8–$12 a week. In 1926, it was listed as McLoud Hotel, located at 143 West New York Avenue. In 1934, it was known as the Albion-McLoud Hotel at 135–137 West New York Avenue and advertised 37 rooms with or without a bath.

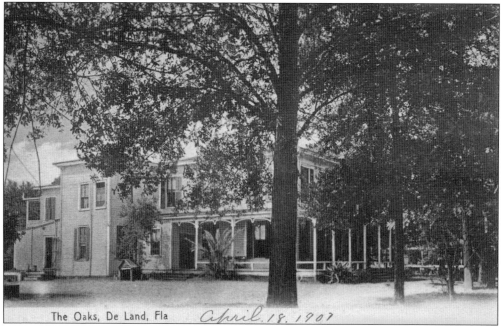

The Oaks, De Land, Fla *April. 18. 1907*

THE OAKS. The Oaks was located on the northeast corner of Clara and Rich Avenues. It was also home to Bert Fish in 1911. In 1926, the Ku Klux Klan lured John E. O'Neill to the hotel under false pretenses, kidnapped him, and beat and partially castrated him, leaving him for dead on the side of the road. The attack was motivated because he was Catholic and was seeing a protestant girl, and because he was an influential leader within the Courthouse Ring.

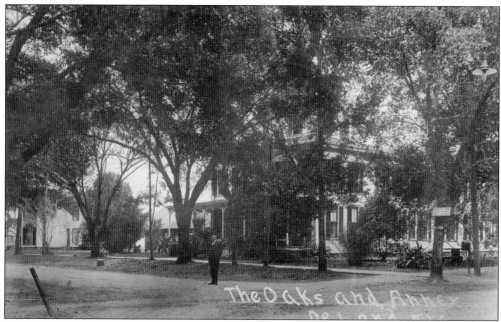

The Oaks and Annex De Land Fla

THE OAKS AND ANNEX. Visible in this photograph is a sign posted on Rich Avenue that states, "Speed limit 10 miles, turning corners 4 miles, and keep to the right." Apparently business was so good that an annex was added to the structure.

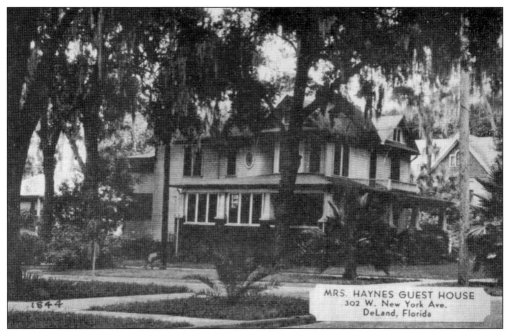

MRS. HAYNES GUEST HOME. Located at 302 West New York Avenue, this boardinghouse, built in 1908, had seven rooms. The structure still stands at the southwest corner of South Clara and West New York Avenues and houses Ryan Insurance & Financial Services.

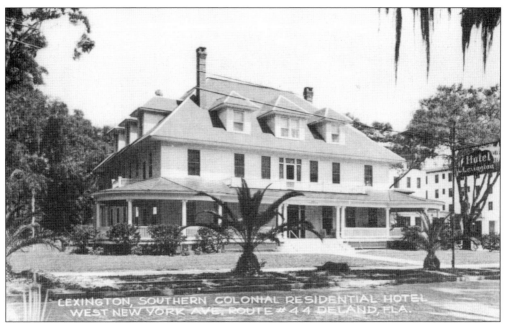

THE LEXINGTON HOTEL. Listings for the Lexington do not appear until the *1917 DeLand City Directory*, which lists Garland Hale as clerk. Bert Fish called this hotel, located at 235 West New York Avenue, home during his time as an attorney and judge. Fish never married, and there is no record of him owning a home in DeLand. Apparently, hotel living suited his busy political life as the leader of the Ring.

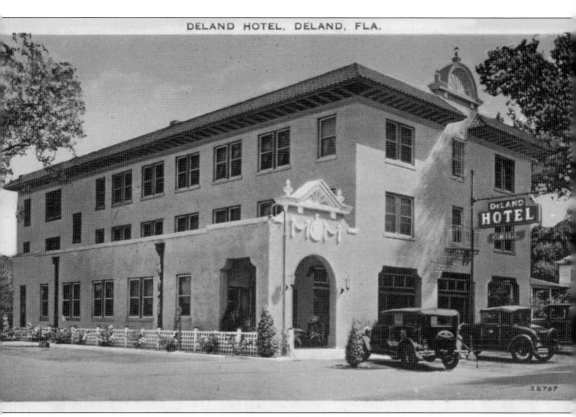

DELAND HOTEL. Located at 215 South Woodland Boulevard at the southeast corner of the intersection of East Howry Avenue, this hotel opened in 1927. It was owned and operated in the 1930s by Mary Stewart Howarth-Hewitt, who was the first female graduate of the Stetson Law School and the first woman to earn a law degree in the state. She was admitted by the Florida Supreme Court to practice on June 20, 1908. After sitting closed and vacant for a number of years, the building was purchased in 1996 by brothers John and Brett Soety from Pennsylvania and completely renovated. It was reopened in 1999 as the DeLand Artisan Inn with a restaurant, hotel, and lounge complete with banquet facilities for small or large groups. New owners have recently reopened it as Artisan Downtown, a boutique hotel, restaurant, and lounge.

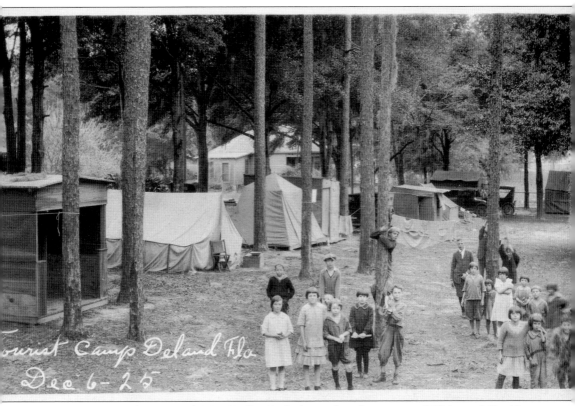

TOURIST CAMP. The DeLand City Trailer Park, located at the corner of Walts and Florida Avenues, provided low-cost facilities for tin-can tourists, named for the canned food they brought along, who visited during the winter months. The rental was 35¢ per day, per car, or $1.50 per week. With the completion of the Dixie Highway in 1915, tourists began to venture south. Samuel Walts donated the land that later became DeLand Trailer Park.

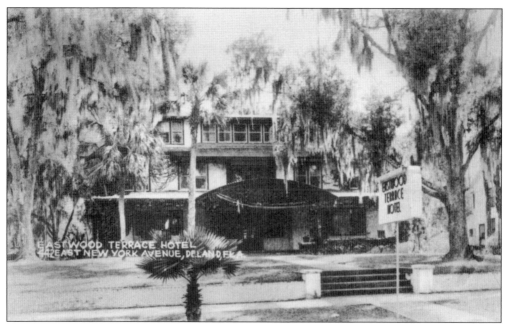

EASTWOOD TERRACE HOTEL. Originally operated as the Eastwood Terrace Hotel from about 1925 until 1975, it was advertised as one of DeLand's finest residential hotels and offered 40 rooms in a three-story building, erected in 1900. Today, the structure at 442 East New York Avenue has been renovated as the Eastwood Terrace Inn, which houses the Palm Restaurant and several shops in addition to the bed-and-breakfast.

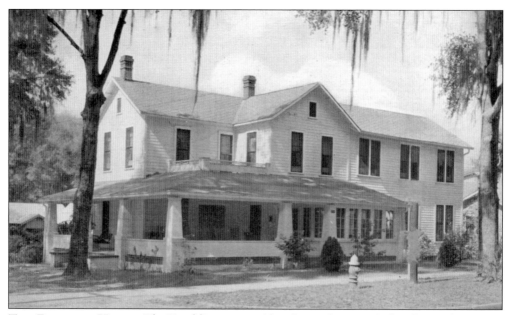

THE FRANKLIN HOUSE. The Franklin was considered a modern tourist hotel in its day. It was located at 344 South Woodland Boulevard and boasted 30 rooms with in-room baths, ample toilet facilities, beds with inner-spring mattresses, and furnace heat. Today, 344 South Woodland is the location of Goodfellow and Company CPA at the corner of West Walts Avenue.

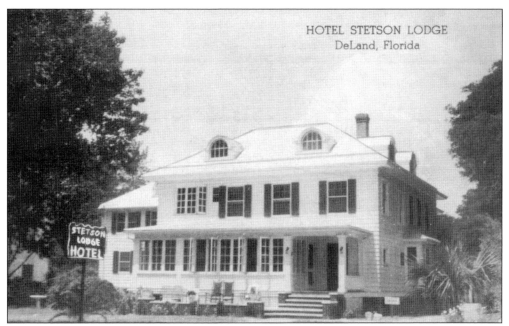

HOTEL STETSON LODGE. Located at 620 North Woodland Boulevard, this lodge offered garage spaces for its guests and homelike rooms with many modern conveniences. This building was managed by a number of people over the years, including Marzee McCarthy in the 1930s and W.R. Jessee in the 1940s. Today, 600–620 North Woodland is the location of the Museum of Art.

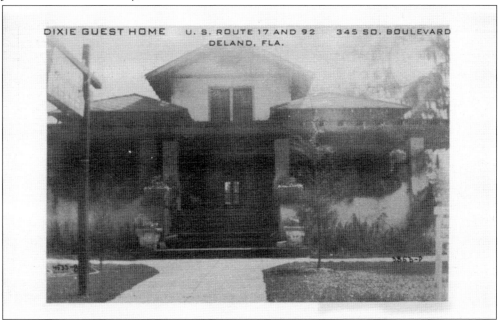

DIXIE GUEST HOME. One of many boardinghouses that offered furnished rooms to tourists, it was located at 345 South Woodland Boulevard. This home was demolished but stood approximately where J.C. Bikes and Boards is located today. A number of other homes on South Woodland Boulevard provided furnished rooms, including the Glatzau home at 241 and the Coll home at 236, which still stands today and is the home of Gordin & Gordin Real Estate.

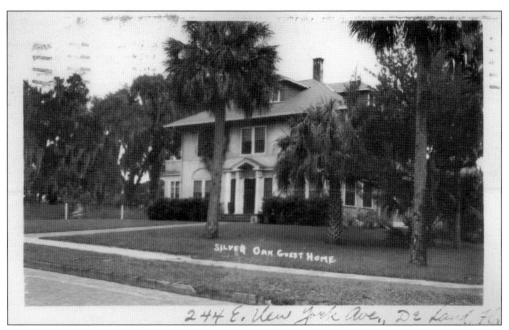

SILVER OAK GUEST HOME. A tourist who thought this was a real nice place to stay sent this postcard, dated 1954. The Silver Oak was located at 244 East New York Avenue, but this house no longer stands. Today, 244 East New York is the approximate location of the DeLand Dental property.

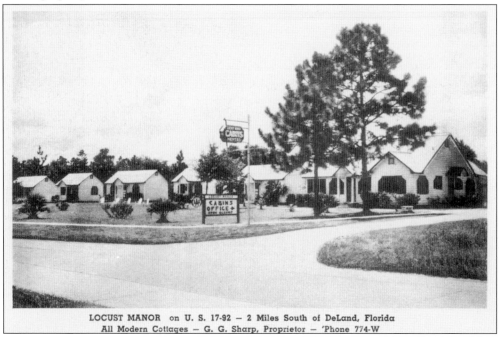

LOCUST MANOR. This tourist court was located at 1500 South Woodland Boulevard, about two miles south of Deland. These heated cabins, operated by G.G. Sharp, were built in the late 1940s or early 1950s. This is the general location of the Dollar General store at the corner of West Chipola Avenue and South Woodland Boulevard.

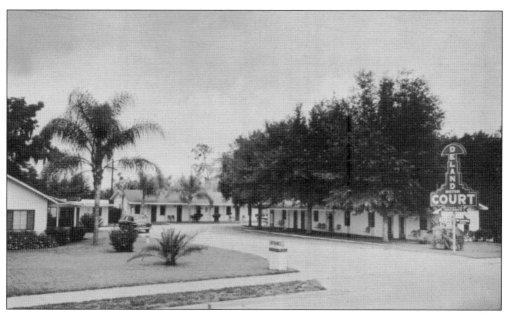

DELAND MOTOR COURT. Opened in the early 1950s, the DeLand Motor Court, or DeLand Motel as it is called today, is located at 1340 North Woodland Boulevard. Owned and operated originally by Mr. and Mrs. Charles Hassell, the DeLand Motor Court featured rooms with tiled baths, vented heat, and air and kitchenettes. There were two restaurants adjacent to the motel, with the Log Cabin Barbecue at 1330 being one of them. When new owners Mr. and Mrs. John Reid took it on, the name was changed.

BOULEVARD MOTEL. In the 1950s, this motel with 27 units at 1349 North Woodland Boulevard charged local kids a quarter to swim in the pool. It is still in operation today, though the pool has been filled in. Built in 1952, it advertised televisions and telephones in each room early on.

DIXIE LODGE. Located at 647 South Woodland Boulevard, the Dixie Lodge was managed by Mr. and Mrs. C.E. Warner, who advertised their property as DeLand's outstanding lodge in the downtown area. The first structures were built in 1950, and additions were added in 1954. It remains open today as an assisted-living facility.

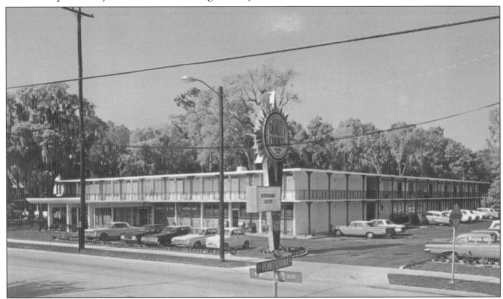

QUALITY COURTS MOTEL AND UNIVERSITY INN RESTAURANT. This facility, built in 1964, is located at 644 North Wood Boulevard. Later, the name was changed to the University Inn. When it opened, it had 60 units, a restaurant, coffee shop, pool, and conference rooms and boasted of closed-circuit television. Stetson University purchased this property in December 2012 to serve its needs, but the university allowed the owners to operate it as a hotel until June 2013. After renovations, the first students occupied their new residence hall in the 2013 fall semester.

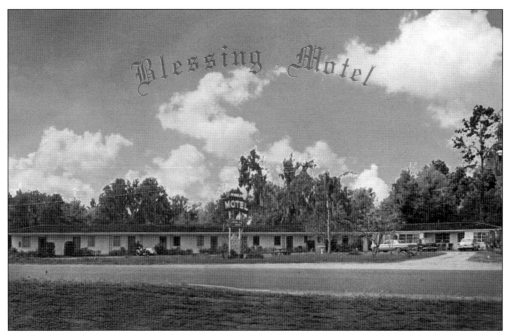

THE BLESSING MOTEL. The Blessing Motel is still in operation at 3460 North Woodland Boulevard. The structure was built in 1952. Originally, it opened under the name Reynolds Motel and was owned by Ella George Reynolds. The card is postmarked 1972 and says the hosts were Mary and Jan Popow. This hotel is located next to and south of the old Rymals Restaurant.

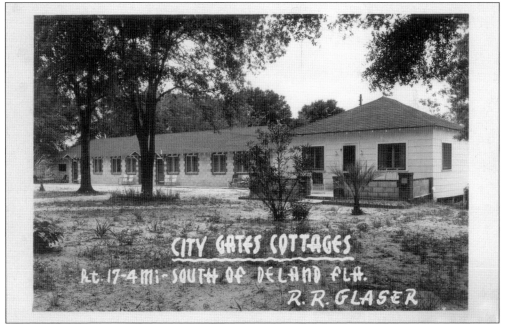

CITY GATES COTTAGES. Located at 2501 North Volusia Avenue (US 17-92), City Gates Cottages, later City Gate Motel, was in north Orange City, just south of DeLand city limits today. It advertised all units as having fireproof masonry construction with modern and fully equipped housekeeping. A Days Inn is located on the property today.

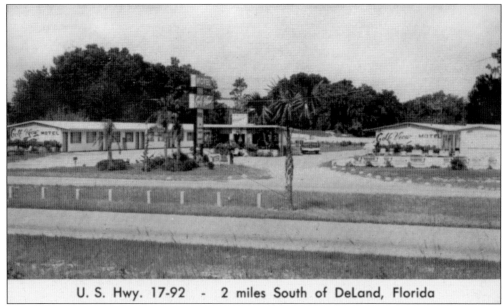

U. S. Hwy. 17-92 - 2 miles South of DeLand, Florida

GOLF VIEW MOTEL. This motel was at the corner of Orange Camp Road and South Woodland Boulevard, about two miles south of DeLand. Presumably, the view the motel was referring to was of the Deland Country Club, which was located on the northeast corner of Orange Camp Road and Woodland Boulevard. In the late 1950s, Mary S. Howarth and Catherine H. Carter managed the motel. It was one of Howarth's many business interests over the years.

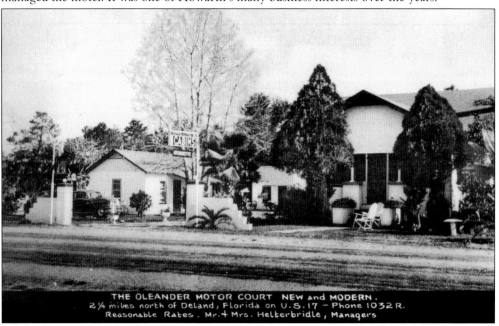

THE OLEANDER MOTOR COURT NEW and MODERN.
2¼ miles north of Deland, Florida on U.S.17 — Phone 1032 R.
Reasonable Rates. Mr. + Mrs. Helterbridle, Managers

THE OLEANDER MOTOR COURT. Located at 1707 North Woodland Boulevard, about two miles north of DeLand, the Oleander Motor Court, later called Oleander Motel in the 1960s, was managed by Mr. and Mrs. Helterbridle, who advertised reasonable rates. The smaller structure appears to have survived and is currently occupied by Credit Auto Inc.; according to the county property appraiser's website, the structure was built in 1932.

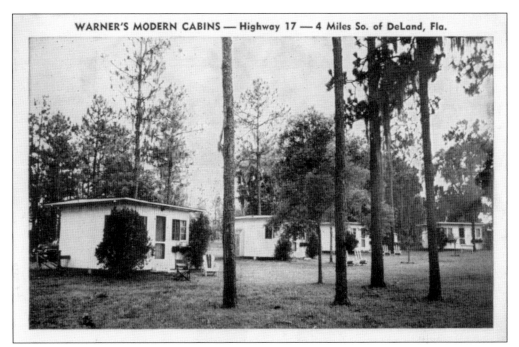

WARNER'S MODERN CABINS — Highway 17 — 4 Miles So. of DeLand, Fla.

WARNER'S MODERN CABINS. Owned by Mr. and Mrs. Gordan C. Warner, Warner's Modern Cabins were located at 1700 North Volusia Avenue at the intersection with New York Avenue, near the DeLand–Orange City line about four miles south of DeLand. It advertised clean, quiet, and comfortable rooms with private showers. The facility also had a beer bar and small gift shop.

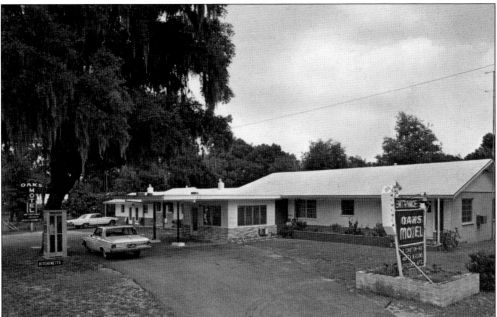

THE OAKS MOTEL. Located at 1319 South Woodland Boulevard at the corner of New Hampshire Avenue and Woodland Boulevard, about a mile south of DeLand, the Oaks was advertised as a friendly little motel. In the 1950s, it was known as Duke's Motel and was managed by Frank Androsky. Today, a Meineke sits on that corner.

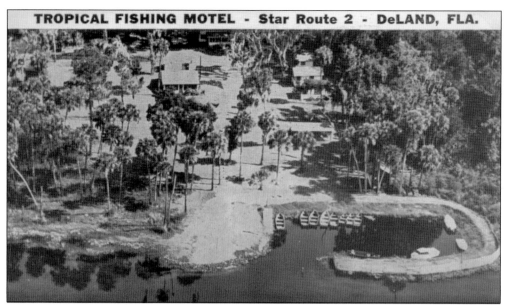

TROPICAL FISHING MOTEL - Star Route 2 - DeLAND, FLA.

TROPICAL FISHING MOTEL. This property overlooked beautiful Lake Beresford, part of the St. Johns River system. It offered individually heated and air-conditioned rooms and fully equipped and furnished efficiency apartments. Tropical Fishing Motel also offered boats, motors, bait, and guide service.

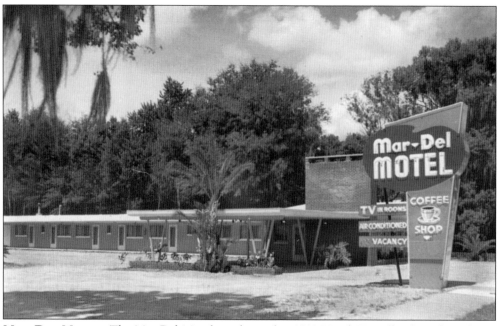

MAR DEL MOTEL. The Mar Del Motel was located at 1010 North Woodland Boulevard, just two blocks north of Stetson University. At the time of construction in 1957, it was surrounded by an orange grove. This postcard was published by Kent's Photo Shop, which was located at 216 North Woodland Boulevard, now the location of Carasells Pop-Culture Collectibles. In 1975, the motel was converted into the Orange Tree Inn.

Seven

REAL PHOTOS, REAL LIVES

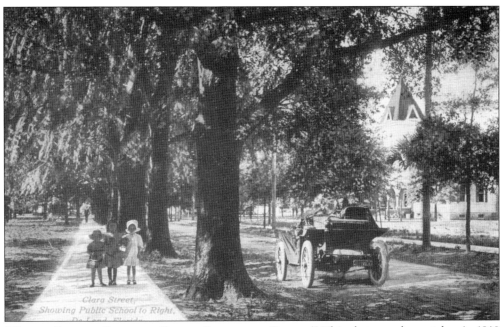

"CLARA STREET, SHOWING PUBLIC SCHOOL TO RIGHT." This photograph was taken in 1910 when, from left to right, Joseph Davis, Delta Richardson, and Sara Davis were walking from their homes on Wisconsin Avenue to kindergarten. They had stopped to pick phlox for their teacher Sarah Hargreaves Brown. Versions of this postcard were sold into the 1930s. Confederate veteran James Jackson Vinzant, who helped build the first home in DeLand belonging to US Army captain John Rich, was the Davis children's grandfather.

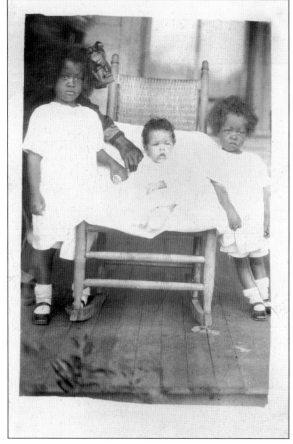

YOUNG WOMAN, OVAL VIGNETTE.
A number of photography studios opened around town at the turn of the 20th century, and many of them offered to convert photographs to postcards. Owen studio took this photograph, but a number of real-photo postcards exist from Gardiner and Reeve and Howard studio.

FROM THE FAMILY SCRAPBOOK OF OLIVER LEE. Presumably, Oliver is in the middle of two family members, possibly sisters, while his mother's arm reaches in from the left. Early-20th-century postcards of African Americans are unfortunately rare. Southern Jim Crow laws and the Great Depression reduced the amount of disposable income available to the average family. One notable exception to this was the family of James Washington Wright, one of the first and most successful black businessmen in DeLand at the turn of the 20th century.

ELIZABETH VIGNIER AND FRIENDS.
Elizabeth was a friend and classmate of
Murray "Pat" Sams at Stetson University.
He went on to graduate from the law
school in 1910 and served as district
attorney for the 7th District, which
included Volusia County in the 1940s
and 1950s. He was from New Smyrna
Beach originally, and his father served
in the Confederacy during the Civil
War. This postcard came from the photo
album he put together while he attended
Stetson. (Author's collection.)

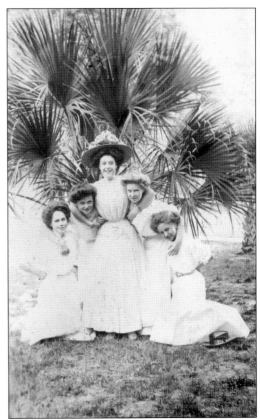

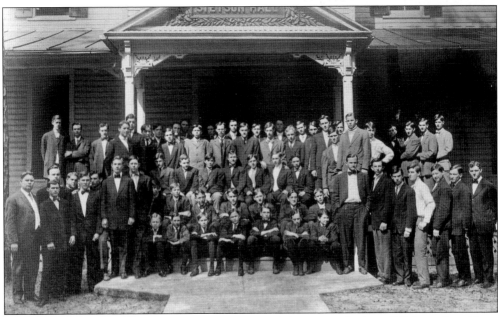

STETSON HALL RESIDENTS. This real-photo postcard depicts a gathering of all the male residents
of Stetson Hall; it was taken in front of the entryway to that building around 1909–1910. Murray
Sams can be seen in the second row, sixth from the right. (Author's collection.)

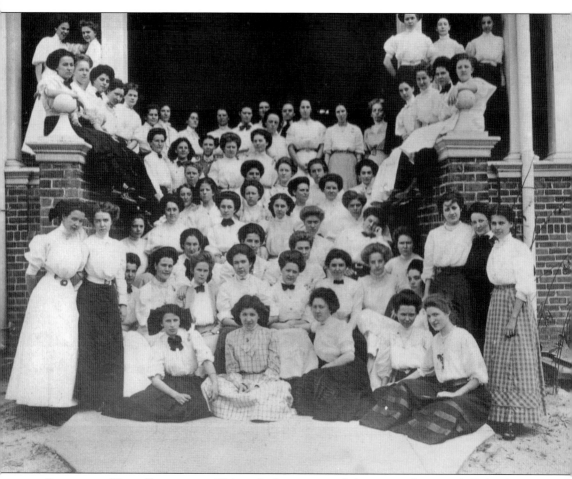

CHAUDOIN HALL RESIDENTS. This real-photo postcard shows a gathering of all the female residents of Chaudoin Hall; it was taken in front of the entryway to that building around 1909–1910. A group photograph of all the residents and staff of each residence hall was an annual tradition in the early years of the school. The 1910 yearbook jokingly refers to the residents as "inmates" and the staff members as "wardens." Elizabeth Vignier can be seen in the center of the photograph. She was born in Switzerland, and her mother and grandmother, both from Pennsylvania originally, lived in Lake Helen during her time at Stetson. (Author's collection.)

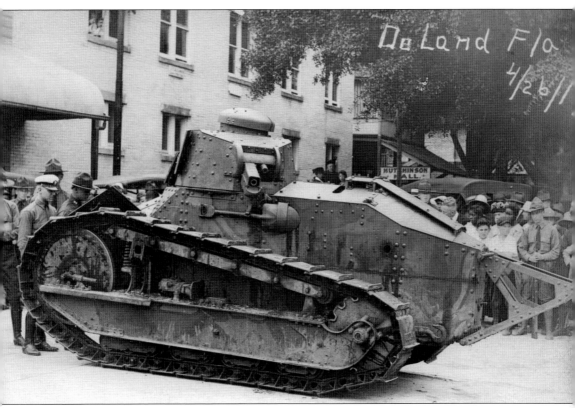

WORLD WAR I TANK. This real-photo postcard documents the day this tank was brought to DeLand on April 26, 1919. Uniformed soldiers with rifles stand around a Whippet tank with onlookers, including what appears to be a DeLand motorcycle policeman. Hutchinson Hall, which was located at 109 East Indiana Avenue, is visible in the background.

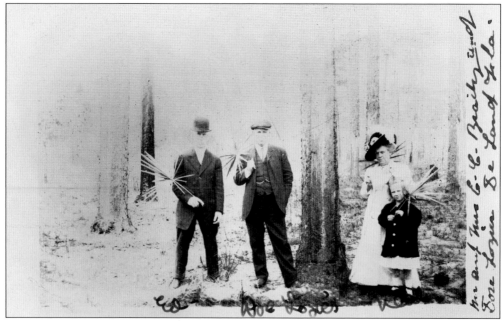

MR. AND MRS. E.C. BRADY. Edwin and Cornelia Brady lived on North Woodland Boulevard in the early 1900s. They hailed from New York, and like many Northerners of that time, they came to Florida to grow oranges. They are pictured with Doe Lozier holding palm fronds in a turpentine orchard where all of the trees have been "cat faced" to cause the sap to flow into the "box," a hole cut into the base of the tree trunk with a box axe. (Author's collection.)

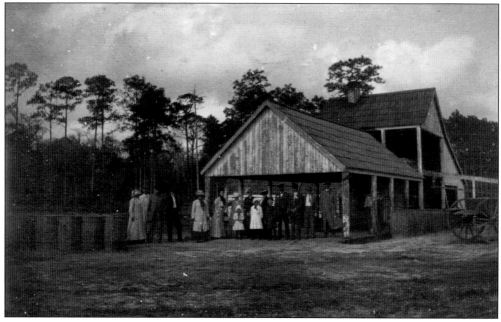

TURPENTINE STILL. Turpentine was made by cutting the bark off pine trees and collecting the sap, which was then distilled. This still was located between DeLand and Daytona. John Tatum, who lived in DeLand, made his fortune from turpentine and owned a number of stills in Volusia County. (Author's collection.)

JOHNNY J. JONES AND HIS TROUPE OF MIDGETS. The Johnny J. Jones Exposition used the DeLand fairgrounds as its winter base of operations until World War II. This unique exposition, which traveled throughout the continental United States and Canada for over 50 years, was named for the man known as "The Mighty Monarch of the Tented World" and "The Midway King" because he was one of the first showmen to purchase steel railroad cars to transport his midway entertainment stages, rows of concessions, and amusement rides. His show was the first in America to reach the 30-car size, growing to 50 cars in the prosperous 1920s. On Christmas Day 1930, Jones, a heavy drinker, died of renal failure at the age of 56 in his private railroad car while wintering in DeLand. His funeral, attended by many showmen, fair executives, local officials, and out-of-state dignitaries, was a big show business event in DeLand. (Author's collection.)

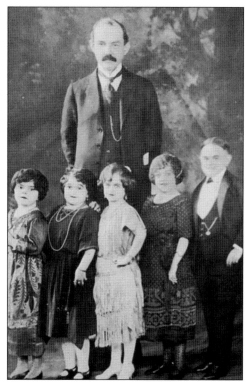

KRUSE BICYCLE SHOP. Carl T. Kruse is standing in front of Kruse Cycle Shop when it was located at 208 North Woodland Boulevard from the 1920s to the 1930s. Prior to this, it was located at 110 North Woodland. This building is the current home of Grotto Beer and Wine. Kruse operated this store for many years in different storefronts along Woodland Boulevard, selling and repairing bikes and motorcycles and providing parcel delivery. By 1939, he moved the business to his home at 545 North Clara Avenue.

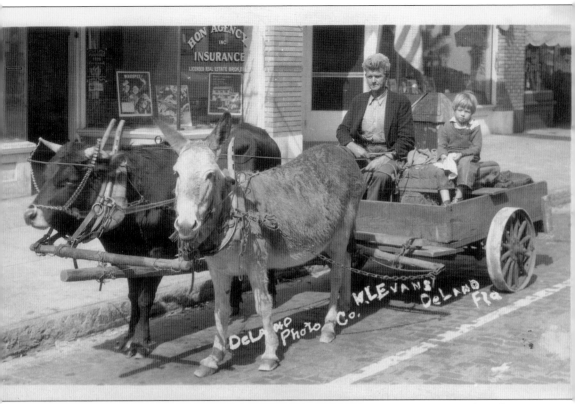

W.L. Evans. Pictured here driving the wagon, W.L. Evans was said to have anywhere from 14 to 22 children, the youngest being in the wagon with him. He sold flowers and garden supplies and liked to entertain tourists during his excursions into town. (Author's collection.)

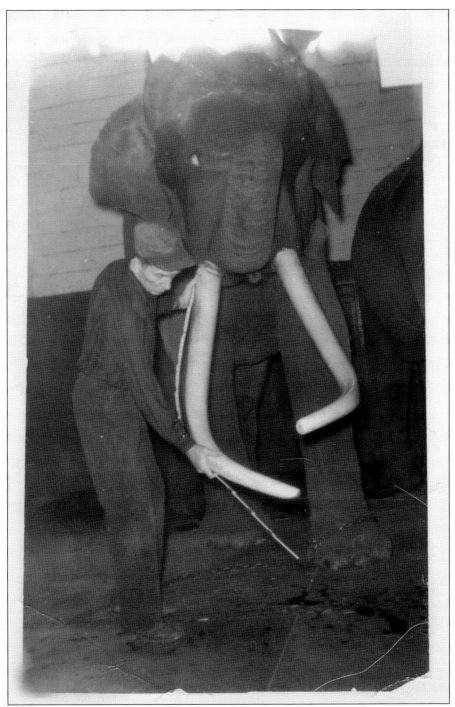

Johnny O'Dell Measuring Tommy. The Clyde Beatty–Cole Bros. Circus wintered in DeLand for many years. The train station off old New York Avenue was where its winter quarters were located. This real-photo postcard states that Tommy weighs 11,180 pounds and is 9 feet high. It also says that Ringling Bros. was supposed to have offered Tony Diano $30,000 for Tommy. (Author's collection.)

DeLand High School Band.
The DeLand High School Marching Bulldogs posed for this postcard on the steps of the historic Volusia County Courthouse in 1964. This image was used in the school's annual, the *Athenian*. The band was heavily involved in fund raising for an upcoming trip to the 1964 New York World's Fair, and this photograph was turned into a postcard for that reason. The three head majorettes were Sonia Crews, Barbara Keen, and Becky Cochran, and the band director was George Wolf. The DeLand High Band has been performing since 1935.

Evelyn T. West. This postcard depicting the entire West family was sent to prospective voters during her 1980 bid for the Florida House of Representatives, District 29, as the Democratic candidate. Evelyn West was the first woman elected to the DeLand City Commission. She and her husband, James, are the only spouses to serve terms as city commissioners, she in the 1960s and he in the 1950s and 1960s. The West family has owned and operated the Stetson Flower Shop since the 1930s.

Eight

PASTIMES

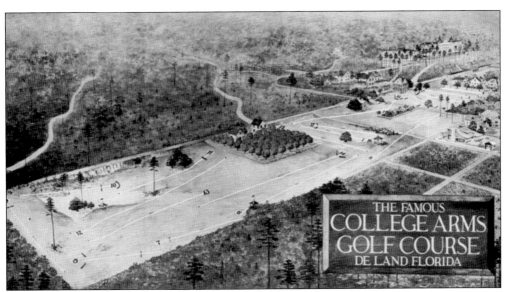

COLLEGE ARMS GOLF CLUB. The first College Arms clubhouse was located in the 300 block of East Howry Avenue at the present site of the Cloisters retirement center. This postcard provides an interesting aerial view of the course layout and the surrounding area. The perspective is looking northwest toward the hotel and downtown DeLand.

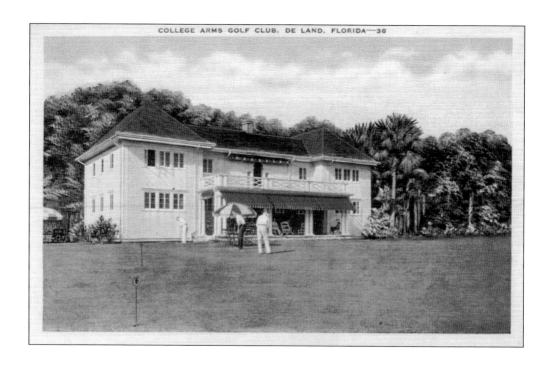

THE FAMOUS COLLEGE ARMS GOLF COURSE. The course's fairways around the structure were maintained by a flock of sheep. In April 1915, it was one of two resort courses in the South with grass greens; the other course was the Belleair Hotel in Augusta. A second clubhouse was built to replace the older structure, but it was demolished in the 1950s after the hotel was torn down.

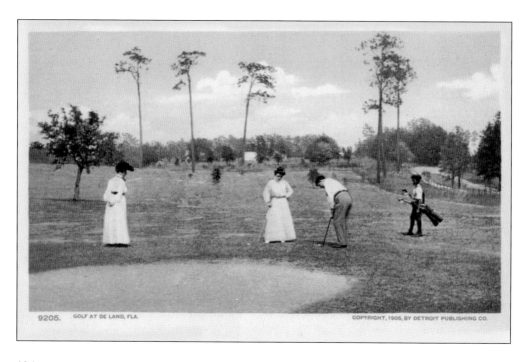

9205. GOLF AT DE LAND, FLA. COPYRIGHT, 1905, BY DETROIT PUBLISHING CO.

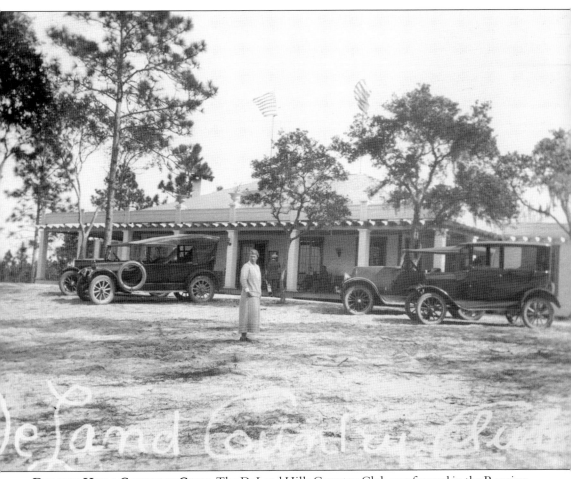

DELAND HILLS COUNTRY CLUB. The DeLand Hills Country Club was formed in the Roaring Twenties during the Florida boom. The original clubhouse, pictured here, was at the same location as the present-day structure. This club operated until the early 1930s, when, presumably, it failed due to the Great Depression. The clubhouse burned to the ground at that time.

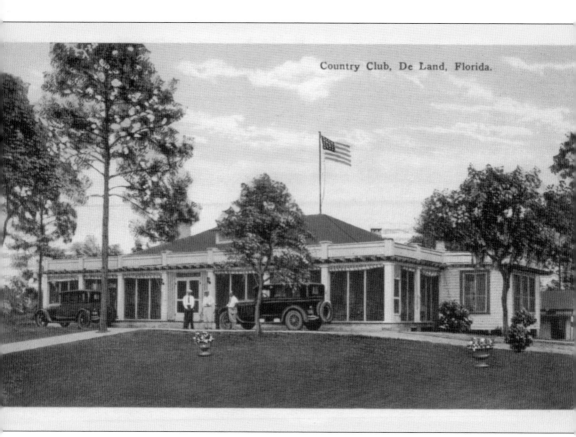

Country Club, De Land, Florida.

DELAND COUNTRY CLUB. The DeLand Country Club was not organized until 1957. On July 1, 1957, US senator George Smather, US congressman Sid Herlong, state representative Jim Sweeney, and Sidney Saloman played an exhibition match there. The second iteration of the DeLand Country Club was located where the first club was built in the 1920s

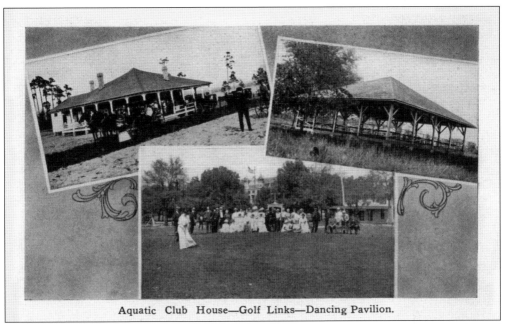

Aquatic Club House—Golf Links—Dancing Pavilion.

"AQUATIC CLUB HOUSE—GOLF LINKS—DANCING PAVILION." The Aquatic Club was located on the west shore of Blue Lake, and it is believed that the location of the dancing pavilion was on the aquatic club grounds, which was also the location of the first county fair about 1914. The golf course belonged to the College Arms Hotel. (Author's collection.)

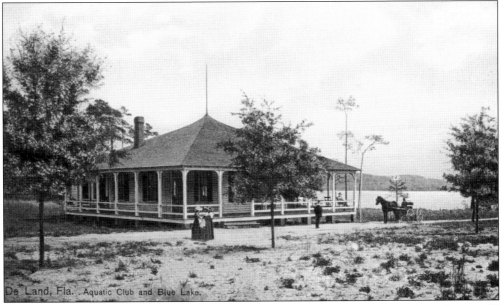

AQUATIC CLUB AND BLUE LAKE. The clubhouse was located on Blue Lake, and members could swim or boat in the lake. This card states that the little gem of water affords unusual aquatic advantages, which were embraced by the members of the club. The building was converted to a home later on. The structure was also used as a meeting place. The Old Settlers Society held meetings here as well as at members' homes and area hotels. The society was formed November 30, 1882, to recognize the settlers of 1875–1876 and 1877.

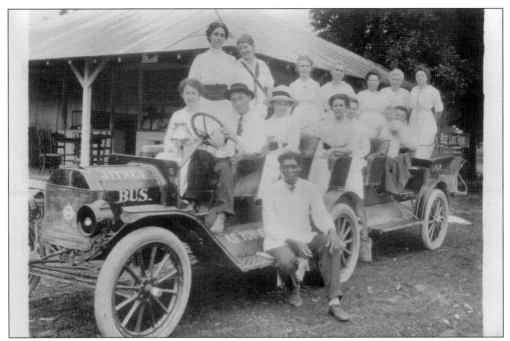

JITNEY BUS. This 10-to-12-passenger vehicle is marked Blue Lake Park on the rear luggage section. Presumably, the jitney offered passenger service to the Blue Lake Aquatic Club. Buses such as this offered service from town to hotels, other communities, and even excursions to the coast.

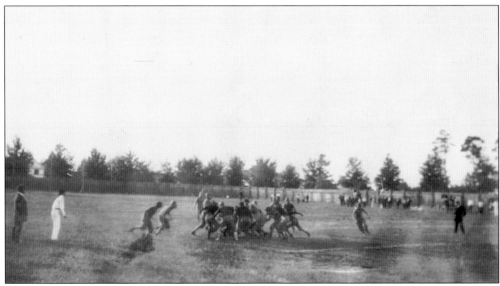

STETSON FOOTBALL GAME. This is a rare view of an early football game played between Stetson and Florida in 1909. They played two games that season. Stetson won the first by a large margin, and they played to a tie in the second game, giving Stetson the state championship. (Author's collection.)

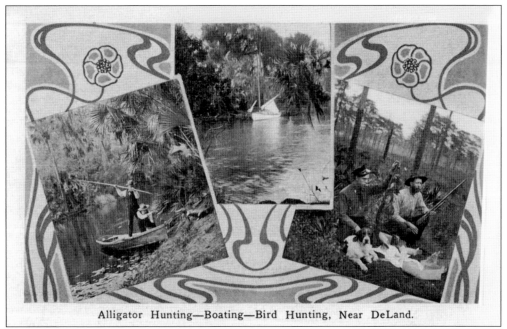

Alligator Hunting—Boating—Bird Hunting, Near DeLand.

"**Alligator Hunting—Boating—Bird Hunting, Near DeLand.**" Sportsmen flocked to DeLand and its close proximity to the St. Johns River to hunt and fish animals of all types. Some birds were hunted to near extinction for their plumage, which was used in hat making. The local hotels had staff dedicated to helping these sportsmen get their trophies prepared for mounting and their return north. (Author's collection.)

Spanish Moss, Lover's Lane. Even before the widespread use of automobiles, the young men and women of DeLand enjoyed parking under the moss-covered oaks of a secluded lover's lane. George Ketner sent this remembrance of that long-forgotten location in 1904.

"Band Shell Showing Honor Roll." The DeLand Band Shell, located at Old City Park or Veterans Park between West Indiana and Rich Avenues, was situated north of the post office. Designed by Medwin Peek, it was built in 1929 and was demolished around 1960. Mounted on the back wall was the Honor Roll of West Volusians serving God and Country. The band, led for many years by Rossie "Pop" Bushnell, played Sunday afternoons. In its later years, the band shell was used for political rallies and outdoor meetings.

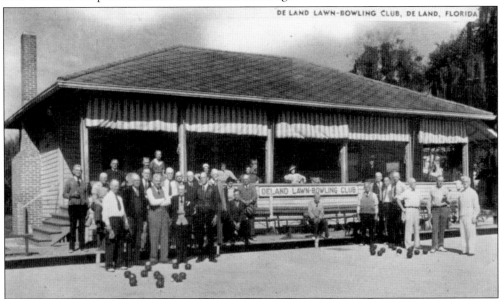

"De Land Lawn-Bowling Club." The club was organized February 1, 1927, by eight original members, W.T. Ainsworth of Mason City, Illinois; John Gill of LaHarpe, Illinois; W.R. Cunningham of Des Moines, Iowa; B.O. Dayton of Mount Vernon, Illinois; and James Gildersleeve, W.A. Martin, W.C. Graves, and G.C. Munn, all of DeLand. The dues were $5 per year. The city provided a site at 213 West Howry Avenue in 1934, which was when the municipal country club was abandoned.

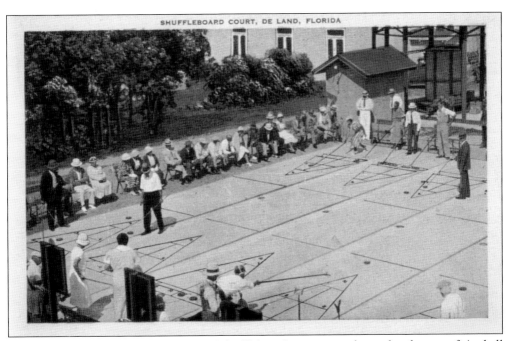

SHUFFLEBOARD COURTS. The DeLand shuffleboard courts were located at the rear of city hall at the southwest corner of New York and Florida Avenues. Checkers tables were also located at this facility; both activities were very popular with Northern winter residents.

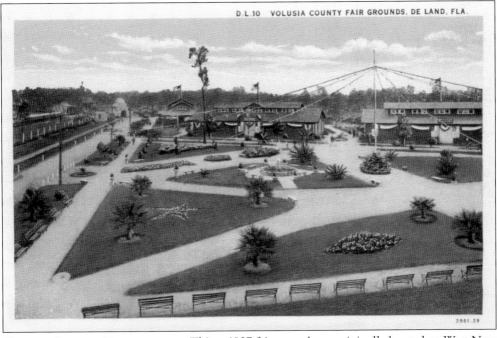

D.L.10 VOLUSIA COUNTY FAIR GROUNDS, DE LAND, FLA.

VOLUSIA COUNTY FAIRGROUNDS. This c. 1927 fairground was originally located on West New York Avenue across from the train depot. When the facility moved to its current location east of DeLand, the Clyde Beatty–Cole Bros. Circus took it over as its winter home.

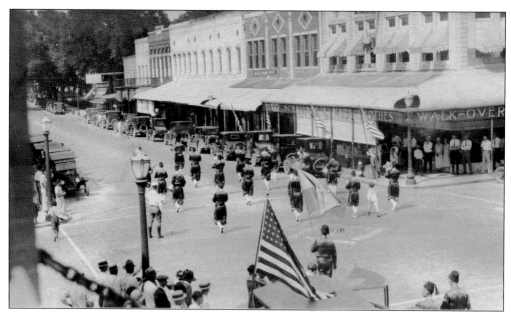

1920S PARADE. This 1920s real-photo postcard was taken from the second floor of the building at the southwest corner of Indiana Avenue and Woodland Boulevard. The Fountain Department Store is clearly visible on the opposite corner. The signs over the sidewalk say, "Hart, Schaffner & Marx Clothing." Next to Fountain's are the telephone office and Watts Hardware and Furniture Co. In the center of the street is a raised grate, with the words "No U Turns" painted on the street around it.

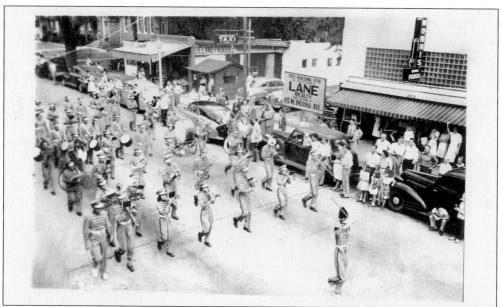

1940S PARADE. This postcard pictures one of the DeLand Christmas parades in the 1940s. In this view of the east side of the 200 block of North Woodland Boulevard, one can see the DeLand Produce Market, which was owned by the Santilli brothers in the 1930s; today, the structure has been the longtime home of Cliff's Books. The building housing Morris's Foods is currently the home of Kenton Shephard CPA.

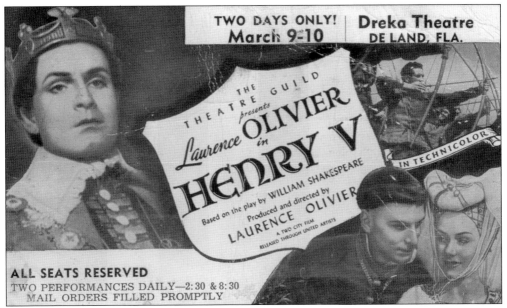

DREKA THEATER. The Dreka Theater was located in a small building on the east side of the larger Dreka Department Store. This postcard was used to advertise the two-day showing of *Henry V* on March 9–10, 1948, with the back of the card being used to mail in seat reservations.

LAKE WINNEMISSET. This lake is located approximately three miles east of DeLand on East New York Avenue. Many beautiful homes were built along the lakeshore, which also had a sandy beach area.

FALLING ANGELS. Chris Ebersole, Jimmy Godwin, and John Gaffney were the DeLand Falling Angels. They were competing for membership on the US Parachute Team at the time this card was produced. DeLand is considered one of the best parachuting destinations in the world.

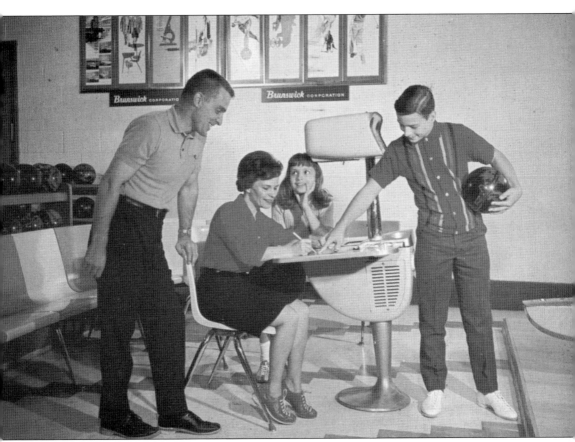

DeLand Bowling Lanes. Brunswick operated the DeLand Bowling Lanes, which opened about 1966 and was located at 1207 South Woodland Boulevard. This bowling alley operated until about 1984, when the Sunshine Bowling Lanes opened at 595 International Speedway Boulevard (US 92). The first bowling alley in DeLand, operated by C.M. Bielby, was located at 104 North Boulevard and offered cigars, tobacco, and soda water. This card soliciting bowling classes was mailed in 1972.

THE NEW WHITEHAIR BRIDGE FROM WAYSIDE PARK. The State Road 44 bridge over the St. Johns River was dedicated in 1955 and named for Francis P. Whitehair, who in 1951 was appointed by President Truman as general counsel for the Economic Stabilization Administration. This post led to his appointment as under-secretary of the Navy later that same year. Whitehair was a graduate of Stetson University College of Law, a partner in the Landis and Fish law firm, and a key leader in the Courthouse Ring. In 1940, Spessard Holland defeated Whitehair in the Democratic gubernatorial primary with the narrowest margin of victory at that time. With no Republican candidate to oppose the victor, the race decided who would be governor. (Author's collection.)

Nine

GREETINGS FROM DELAND

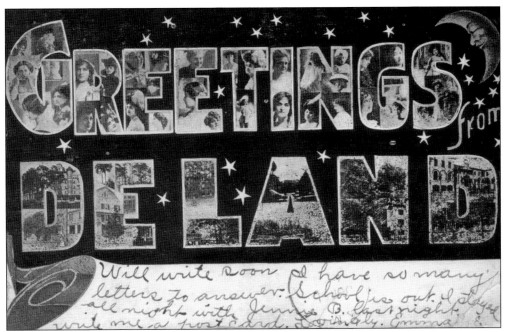

GREETINGS FROM DELAND. The first souvenir postcard in the United States was printed in 1893 to advertise the World's Columbian Exposition in Chicago. Until May 19, 1898, the Post Office was the only institution authorized to print postcards when the Private Mailing Card Act was passed by Congress. This act allowed private publishers and printers to produce postcards. Deland's growth as a tourist destination and a cultural center tracked closely with Stetson University's expanding facilities, staff, and students, creating a need to send a quick note home to friends and loved ones.

PRIVATE MAILING CARD. Prohibited by the Post Office from calling their cards postcards, private printers called them "souvenir" cards and had to label them Private Mailing Cards (PMCs). Postcards were not allowed to have a divided back and senders could only write on the front. This was known as the "undivided back" era of postcards. On March 1, 1907, the Post Office allowed private citizens to write on the address side of postcards, which were then allowed to have a divided back. This was the golden age of the postcard. Two early examples of PMCs are shown here: the one above with a Stetson theme was sent in 1901, and the one below with street scenes was sent from Chris O. Codrington inviting a fellow member of the Myrtle Lodge of the Knights of Pythias to a July 23, 1903, meeting. (Below, author's collection.)

Dear Sir and Bro:
 The Chancellor Commander requests
that you be present at the meeting of
Myrtle Lodge, No. 21, K. of P., Thursday
evening, July 23, 1903. Work in the Rank
of Knight.
 Yours in F., C. & B.,
 Chris. O. Codrington,
 K. of R. & S. and M. of F.

You are to prepare for
C. C. in case of necessity

DeLAND, VOLUSIA COUNTY, FLA. 190

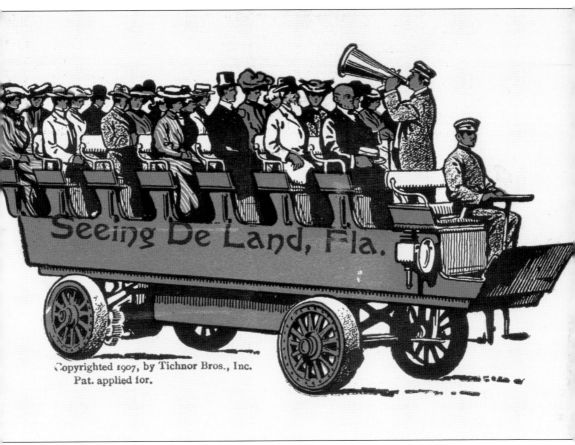

Copyrighted 1907, by Tichnor Bros., Inc.
Pat. applied for.

"SEEING DE LAND, FLA." This 1907 postcard by Tichnor Bros. Inc. depicts an early 21-person tour bus full of people, a guide, and a driver heading out to see the sights of DeLand.

— D-13

"Greetings from DeLand Florida." Postcards of this nature would have been available from Brill's or the Reeve and Howard Old Curiosity Shop at 105 West Indiana Avenue. Established in 1905 by Grace Howard and Edith Reeve after their graduation from Stetson University, this gift shop may have been one of the first woman-owned businesses in DeLand or even the state. This is one of many generic DeLand postcards.

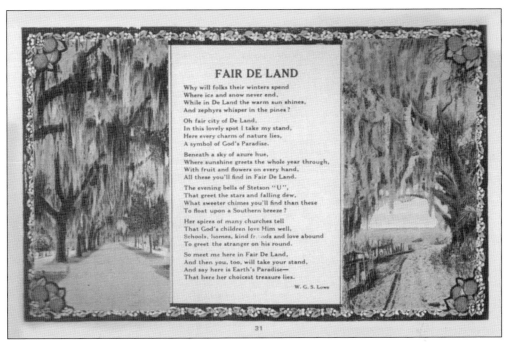

FAIR DE LAND

Why will folks their winters spend
Where ice and snow never end,
While in De Land the warm sun shines,
And zephyrs whisper in the pines?

Oh fair city of De Land,
In this lovely spot I take my stand,
Here every charm of nature lies,
A symbol of God's Paradise.

Beneath a sky of azure hue,
Where sunshine greets the whole year through,
With fruit and flowers on every hand,
All these you'll find in Fair De Land.

The evening bells of Stetson "U",
That greet the stars and falling dew,
What sweeter chimes you'll find than these
To float upon a Southern breeze?

Her spires of many churches tell
That God's children love Him well,
Schools, homes, kind friends and love abound
To greet the stranger on his round.

So meet me here in Fair De Land,
And then you, too, will take your stand,
And say here is Earth's Paradise—
That here her choicest treasure lies.

W. G. S. Lowe

31

"FAIR DE LAND." These excerpts are from a poem by W.G.S. Lowe: "Why would folks their winters spend / Where ice and snow never end, / While in De Land the warm sun shines, / And zephyrs whisper in the pines . . . The evening bells of Stetson "U", / That greet the stars and falling dew, / What sweeter chimes you'll find than these / To float upon a southern breeze? / Her spires of many churches tell / That God's children love him well, / Schools, homes, kind friends and love abound / To greet the stranger on his round."

12 VIEWS OF DE LAND. This US mail card was one from the 1907 letter carrier series. Users could only put the address on the back, and many of these were sent as just as a souvenir, with no writing on the front of the card. The letter carrier's mail pouch contains 12 views of De Land, which were folded to fit inside. The views were of the College Arms Hotel and Golf Club, Woodland Boulevard, Chaudoin Hall, Pine Apples, Downtown Woodland Boulevard, Elizabeth Hall, Orange Grove, St. Johns River, School of Technology and Hall of Science, floating in Florida, and Spanish moss. (Author's collection.)

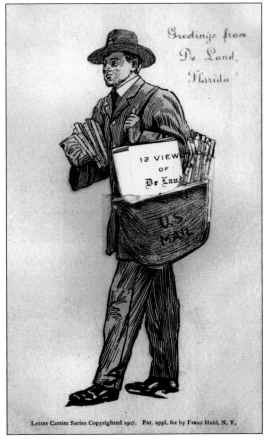

Letter Carrier Series Copyrighted 1907. Pat. appl. for by Franz Huld, N. Y.

A Papoose in Carrier. Another early postcard souvenir features a Native American infant in a carrier adorned with ancient Anasazi symbols representing the center of Hopi land, which resemble Nazi swastikas. Enclosed in the carrier along with the infant are 24 views of DeLand, many similar to the letter carrier series.

Greetings from DeLand. This aerial view taken in the 1950s from the DeLand Motel rooftop looks north along Woodland Boulevard at the intersection of Howry Avenue. The First United Methodist Church building is in the foreground on the right; opposite it on the west side of the street is the old Masonic Lodge building built in 1925, which is called the Mix Building today with a variety of stores and offices. The Texaco gas station just north of the church is the site of Checkers today and the building north of that has been torn down and converted to parking for the Dreka/Whitehair Building.

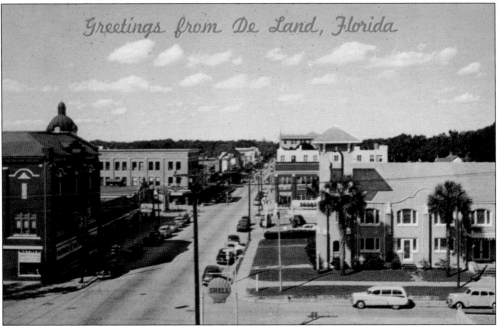

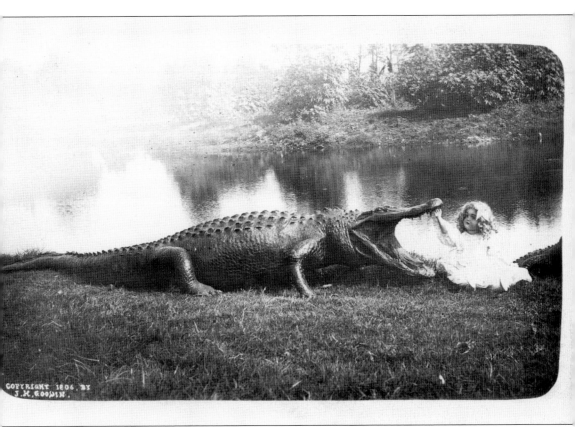

ALLIGATOR AND BABY DOLL. This unusual view was sent as a real-photo postcard in 1910; it depicts the ever-popular alligator that so fascinated winter visitors to the state. Many variations of this theme, most staged with stuffed gators, can be found on mass-produced and individually created postcards.

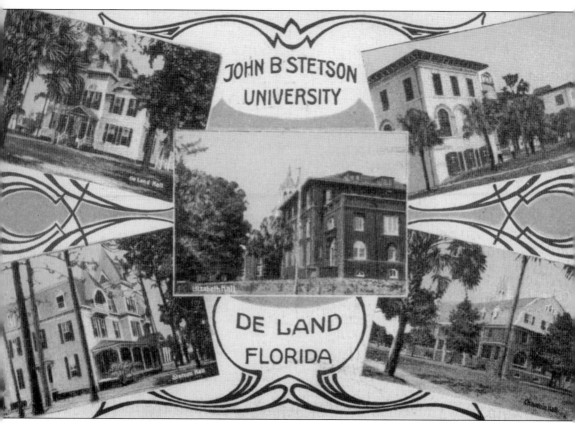

JOHN B. STETSON UNIVERSITY. This card contains five views of Stetson University's most famous buildings. Students now had a way to send quick notes home without penning an entire letter. All of Stetson University's highest profile buildings of the day, including DeLand Hall, Stetson Hall, Elizabeth Hall, Flagler Hall, and Chaudoin Hall, are depicted.

BIBLIOGRAPHY

Caccamise, Louise Ball. *Memory Lane: A History of the Street Names of DeLand, Florida*. DeLand: West Volusia Historical Society, 2013.

DeLand City Directory 1907. DeLand: E.O. Painter Printing Co., 1907.

DeLand City Directory 1924–1925. Jacksonville, FL: R.L. Polk & Co., 1924.

DeLand, Florida, City Directory. Asheville, NC: Florida-Piedmont Directory Co., 1917.

DeLand, Helen Parce. *Story of DeLand and Lake Helen, Florida*. Norwich, CT: Academy Press, 1928.

Dreggors, William J. Jr. and John Stephen Hess. *A Pictorial History of West Volusia County 1870–1940*. DeLand: West Volusia Historical Society, 1989.

Dreggors, William J. Jr. and John Stephen Hess. *A Century of West Volusia County 1860–1960*. DeLand: West Volusia Historical Society, 1993.

Franke, Arthur E. Jr., Alyce Hockaday Gillingham, and Maxine Carey Turner. *Volusia: The West Side*. DeLand: West Volusia Historical Society, 1986.

Gold, Pleasant Daniel. *History of Volusia County Florida*. DeLand: E.O. Painter Printing Co., 1927.

Lycan, Gilbert L. *Stetson University: The First 100 Years*. DeLand: Stetson University Press, 1983.

Reflections. DeLand: City of DeLand, 1976.

The Odyssey of an American School System: Volusia County Schools 1954–2000. DeLand: Volusia County Schools, 2000.

Volusia County Property Appraiser. www.volusia.org/services/property-appraiser.stml

DISCOVER THOUSANDS OF LOCAL HISTORY BOOKS
FEATURING MILLIONS OF VINTAGE IMAGES

Arcadia Publishing, the leading local history publisher in the United States, is committed to making history accessible and meaningful through publishing books that celebrate and preserve the heritage of America's people and places.

Find more books like this at
www.arcadiapublishing.com

Search for your hometown history, your old stomping grounds, and even your favorite sports team.